M

PAPER POLITICS

PM PRESS | 2009

Paper Politics: Socially Engaged Printmaking Today
edited by Josh MacPhee

with essays by Deborah Caplow and Eric Triantafillou

ISBN: 978-1-60486-090-0
Library of Congress Control Number: 2009901385

Sue Coe: *We are All in the Same Boat*
© 2005 Sue Coe
Courtesy of Galerie St. Etienne, New York

PM Press
POBox 23912
Oakland, CA 94623
PMPress.org

Cover and internal design by Josh MacPhee/Justseeds.org

Printed in the United States.

PAPER Soc

Josh MacPhee

ly Engaged Printmaking Today

with essays by Deborah Caplow and Eric Triantafillou

table of contents

Swoon, *let the warmongers tremble*, 2004
linocut, 11" x 17"

Politics on Paper

Josh MacPhee

EVERY PRINT IN THIS BOOK was printed by human hands: linoleum was carved, copper was scratched, cardstock was cut, photo paper was dipped in developing chemicals. These types of traditional printmaking are not the dominant form of communication today. They can't compete with billboards or bus ads, never mind television or the Internet. Yet these printmaking methods remain vital, maybe even because of their anachronistic existence. We rarely see any evidence of the human hand in our visual landscape, just digitally produced dot patterns and flickering electronic images. This gives handmade prints affective power—stenciled posters pasted on the street or woodcuts hanging in a window grab the eye; they jump out at us because of their failure to seamlessly fall in line with the rest of the environment.

There is a contradiction here. Our prints can stand out from the pack, but only if we print them in small batches by hand. If the goal of political printmaking is communicating ideas, and we want those ideas to reach as many people as possible, does it really make sense to be printing seventy handmade posters in the age of mass production? This is just one of the many questions and conundrums that continually bring me back to printing by hand. There is something in the act of spreading ink on a wood block or pulling ink through a screen with a squeegee that can create a powerful connection between printer and print and audience. What this connection can do I am unsure of. I've asked many of the artists in this book why they still continue to print by hand, and you'll find their answers throughout this book.

My own interest in printmaking began in the street. I became interested in street stenciling after seeing stenciled art in the political comic book *World War 3 Illustrated*, and quickly became obsessed with the art form. For fifteen years I regularly stenciled prints directly onto streets across the country. I've also tried my hand at linocuts, and am currently an active

Paper Politics Chicago, 2004
photographs by Brandon Bauer

screen printer. At the core of my interest in all these printmaking forms is their simplicity, accessibility and inexpensive charm. You can make hundreds of copies of a print in a couple of hours, and then hand them out to friends, sell them for cheap, or paste them on the street. A quick look at main streets in most urban areas and it's clear I'm not the only one who feels there is power in public displays of printmaking.

Paper Politics started out as an exhibition of political prints, and has now taken the form of this book, but it has always also been a project of building communities. In early 2004, I organized the first *Paper Politics* art show in Chicago as a fund raiser for a small group of social movement-minded street artists I was a part of called the Street Art Workers (Streetartworkers.org). It was an experiment. I had a loose network of contacts with fellow political print and poster makers—most of them, like me, young with little formal training in printmaking. I also had a hunch that there was a wide audience for this type of scrappy, socially-engaged printmaking. *Paper Politics* was an attempt to actualize both a community of printmakers and a more specific audience for our work than the existing "anyone that happens to see it on the street."

A half dozen artist friends from around the Midwest converged on Chicago and helped hang the show, not in an art gallery, but in the offices of the magazine *In These Times*.

This project grew out of the Do It Yourself (DIY) ethic and community, and out of the idea that artists can create their own exhibitions without galleries, professional curators, or wealthy art collectors. Six of the artists that helped (Alec Icky Dunn, Nicolas Lampert, Colin Matthes, Erik Ruin, Shaun Slifer and Mary Tremonte) would go on to become members of the Justseeds Artists' Cooperative, an artist-owned and -run collective and online gallery in which I currently participate. (Sixteen of the fifty artists involved in the first show have ended up as members of Justseeds.) The response to the show was overwhelming. Hundreds of people came to the opening, and we sold over $2,000 worth of prints, all for $25 or less. People were literally fighting to get in line to buy political prints. I had never seen anything like it. I still get emails from people who came to that opening night, asking what's happening with *Paper Politics* and what's going on in this part of the political print world.

The staff at *In These Times* not only gave us free space to hang the show, they also ran a couple short features and images from the show in their magazine. Luckily, Joseph Pentheroudakis, then the President of Seattle Print Arts, saw one of the features and contacted me about re-creating the show in Seattle. Together we put out an open call, and through our combined networks of punk rock poster makers and more professional and trained printers, we built a new collection of 174 works by 174 different artists.

And unlike the Chicago show, which was almost exclusively made up of do-it-yourself stencils, screen prints and linocuts, **Paper Politics** now had raw and dirty spray painted stencils on old dumpstered blueprints hanging next to precise and fine art intaglios on Arches paper. The work collected in Seattle became the core of the exhibition and this book. Over the next four years the show has travelled to Brooklyn; Corpus Christi, Texas; Cortland, New York; Milwaukee; Montreal; Portland, Oregon; Syracuse, New York; Richmond, Virginia, and Whitewater, Wisconsin. At each stop it has collected new work. It has shown in community centers, artist-run spaces, university art galleries, and an empty warehouse. Artists have met each other and audiences, and built long-term, nurturing relationships.

Art exhibitions that express clear positions on social issues are rare. They may happen sporadically in major cities, but I've found that **Paper Politics** has received an outpouring of interest in smaller cities and non-urban centers. Many of the shows have been organized or hosted by printmakers with work in **Paper Politics**, and holding events in their locale has allowed them to reach out and connect with like-minded artists. In Milwaukee, the opening was one of the largest ever at the Walker's Point Center for the Arts, and in Richmond dozens of people expressed excitement that there was a show in their town that directly discussed labor issues, the ongoing wars in Iraq and Afghanistan, struggles around immigration and borders, and problems with the U.S. electoral system.

* * *

For most of my adult life I have been struggling with the tension between being an activist and being an artist. I have often found that most of the art world, including street artists, are dismissive of cultural work with explicitly political content. At the same time, political activists and organizers are just as likely to reject art and aesthetics in their campaigns, supposedly in the name of utility. For me, both art and politics are about communication and also about community. As much as a collection of individual art works, **Paper Politics** is an exercise in large scale social organization, the bringing together of the political insight and creative energy of almost 200 artists from over a dozen countries and over seventy-five cities, suburbs and small towns.

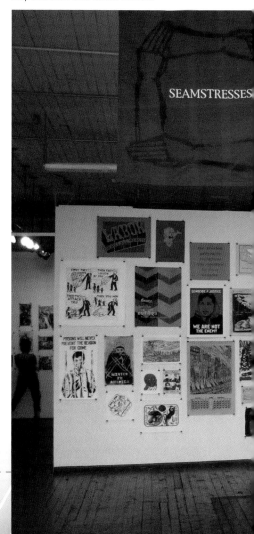

Paper Politics **Milwaukee**, 2007
photograph by Josh MacPhee

Positive social change comes to our world from protest movements, organized labor actions, mobilized communities, large-scale boycotts, and sometimes even voting, civil disobedience, and guerilla warfare. What connects all of these disparate actions is that they are immense, organized social activities made up of politicized individuals. Today's world atomizes us and boxes us up as little individual units, often crushing our ability to view ourselves as part of something larger than our own privatized consumer choices. Artists are doubly under the heel of this atomization, both from the larger society and also from modernist conceptions of the individual genius artist,

locked in isolation, generating beauty and wonder for everyone else. This is why **Paper Politics** is practically overwhelming in scope and volume. I don't want to live as a singular artist; I want to participate in building a strong thriving community. Individually the works in this show range from stunningly beautiful art prints with subtle political implications, to bold, bull-dozing pieces of printed propaganda.

That said, this is a project that has its origins squarely in the George W. Bush era. The year 2004 was a time of intense fear on the political left; we were still reeling from the double blows of September 11th

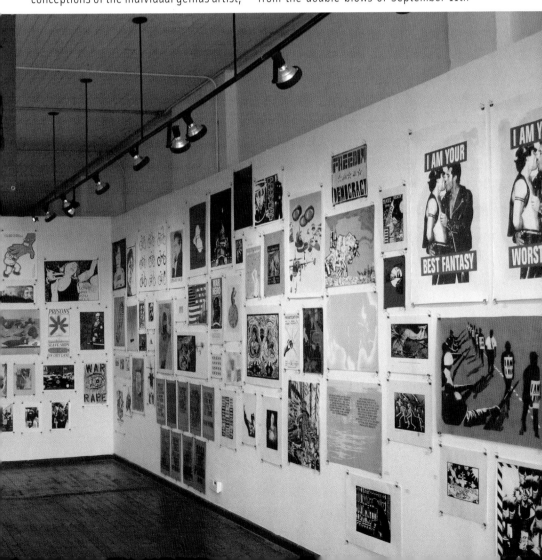

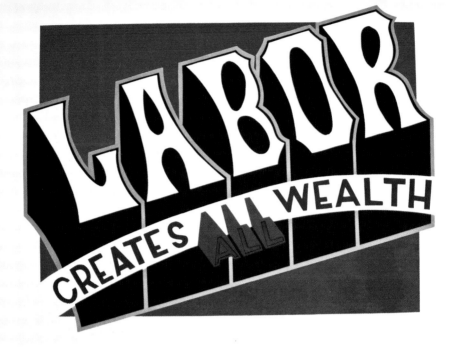

Josh MacPhee, *Labor Creates All Wealth*, 2007
screen print, 25" x19"

and the failure of the anti-war movement to stop the U.S. from invading Iraq. I felt we needed a project to give voice to the multiplicity of our angers, frustrations, aspirations, hopes, dreams, and fears. But times change, and so do our political and cultural needs. In 2005, over a dozen of the prints included in *Paper Politics* referenced Bush directly, with double that amount referencing his policies and actions in office. I've cleaned out most of the Bush prints in hopes of keeping this book relevant and a little less dated.

But there are deeper changes at work. In the period from 2004 to 2008, I felt that we needed a united front, that all political expression was important, and that such expression needed to be aggregated in order to amplify each of our individual voices. I'm not so convinced of that today. Rather than seeing all of the work bound under these covers as different inflections of the same voice, I think it is now time to start to explore what

our real differences are. Are all the pieces here really asking for the same thing? Does this amalgamation of ideas, none seen as more valuable or important than any other, have the power or force to convince people we need to change the world?

These are but a few of the difficult questions political printmakers need to ask themselves. This messy aggregate called *Paper Politics* is a starting point, the beginnings of an aesthetic conversation about what is wrong with the world we inhabit and what a new society we want to live in might look like. To that end, I've asked Deborah Caplow to write about the history of political printmaking, and Eric Triantafillou to write about the intersection of art and politics and the possibilities of a path forward. In addition, the images reproduced here are sprinkled with the words and ideas of those who printed them, giving voice to why we print by hand, what we hope to gain, and to whom we hope to speak.

exhibition history

2009 **Ghostprint Gallery**
 Richmond, VA USA

2008 **Dowd Gallery/SUNY-Cortland**
 Cortland, NY USA

 K Space Contemporary
 Corpus Christi, TX USA

 Red House Gallery
 Syracuse, NY USA

2007 **L'Art + Anarchie Salon**
 Montréal, QC Canada

 Crossman Gallery/University of Wisconsin-Whitewater
 Whitewater, WI USA

 Walker's Point Center for the Arts
 Milwaukee, WI USA

2006 **5+5 Gallery**
 Brooklyn, NY USA

 Food For Thought Gallery
 Portland, OR USA

2005 **Phinney Center Gallery**
 (in association with **Seattle Print Arts**)
 Seattle, WA USA

2004 **In These Times**
 Chicago, IL USA

Political Art and Printmaking: A Brief and Partial History

Deborah Caplow

ALL ART HAS POLITICAL IMPLICATIONS, but socially conscious art actively protests against war, injustice and corruption. This kind of art is a recent phenomenon, appearing first in paintings and prints by Francisco Goya at the beginning of the nineteenth century. While many artists painted images with political intent, printmaking has a special advantage. Because of its reproducibility, low cost and potential for graphic expressiveness, the print is an ideal way to voice opposition. Prints are often a form of public art, as they are circulated widely outside the private sphere. Political prints have always been intended to engage the viewer, change opinion and inspire action. In the twentieth century, waves of printmaking throughout the world reflected the importance of communicating urgent messages to wide audiences; in Europe, the U.S., China, and Mexico, printmakers worked collectively to generate powerful images that reflected the social conditions of the times.

The printmaking medium is generally not accorded the status of painting or sculpture and does not traditionally have a high market value. Artists who are known for their printmaking, like Rembrandt and Goya, are included in the canon of art history primarily because of their paintings, while printmakers like Käthe Kollwitz are much less well known. In addition, prints often have an ephemeral quality and some of the best, pasted on walls or distributed as leaflets, are rare, while some, like those of Goya, Daumier and Manet, were banned because of their controversial nature. Posters and broadsides are timely and topical, and book illustrations are not intended as autonomous art objects. Political art has often been labeled as propaganda in efforts to defuse its power, and mainstream art criticism and art history in the U.S. have marginalized representational political art since the late 1940s. Very few exhibitions and books have been published

on this subject, and only recently have critics and art historians taken political art as a serious topic for discussion.

Goya created both painted and printed images to protest the war and folly of his time. His epic, large-scale *Executions of the Third of May, 1808*, of 1814, is a grim reminder of the continuity of history. Goya painted a group of citizens of Madrid, insurgents against the forces of Napoleon's army, waiting their turns as the French invaders shoot them down in a hellish nocturnal scene, one man's white shirt and outstretched arms a cry of martyrdom that stands for all innocent victims throughout time. Goya's etchings in the series *Los Caprichos (Caprices)* and *Los Desastres de la Guerra (The Disasters of War)* also comment directly on issues of his time. He provided a brilliant and complex critique of human folly in his print *The Dream of Reason Brings Forth Monsters*, and he bitterly condemned the violence of the Napoleonic War in Spain in the first decade of the nineteenth century in such prints as *I Saw It*. Here Goya offers first-hand testimony and, by extension, involves the viewer as a fellow witness in acts of atrocity. He was the first to depict war without glory or purpose, instead focusing on the terror experienced by the civilian population—truly a disaster in human terms.

Two decades later, the French painter/printmaker Honoré Daumier made thousands of lithographs denouncing cruelty and corruption in France. Daumier's

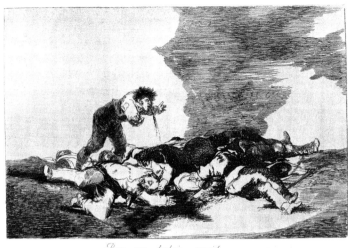

Para eso habeis nacido.

Francisco Goya, *This is what you were born for*, 1810-20 (from *The Disasters of War* series) aquatint, 8" x 6"

dramatic scene of police brutality in his accusatory *Rue Transnonain, 15th April, 1834* depicts three generations of a working-class family murdered in the bedroom of their Paris apartment by government forces. Like Goya in *Executions of the Third of May, 1808*, Daumier dated the image to anchor it in a specific time and place, but such an image could have been created in Mexico City in 1968 after the student massacre in the Plaza of Tlatelolco, during which innocent residents of surrounding buildings were also killed in their own homes. Daumier's 1831 lithograph *Gargantua*, portrays King Louis-Philippe devouring the food and money of the poor. This work earned him a six-month jail term for his audacity in opposing injustice and corruption.

Painter Edouard Manet also commented on current events in his *Execution of Maximilian* of 1867. Manet based this image directly on Goya's *Executions of the Third of May, 1808*, directing his criticism at the Emperor Napoleon III, who had helped Maximilian invade Mexico in the

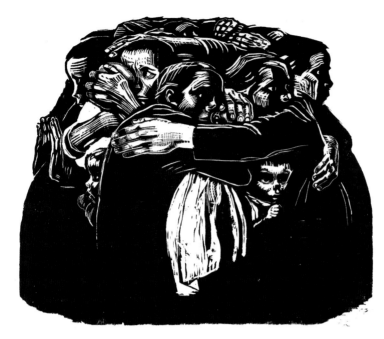

Käthe Kollwitz, *The Mothers*, 1922-23
woodcut

revolutions and class struggles that followed. In Germany, artists such as Käthe Kollwitz, Otto Dix, and George Grosz used their prints to attack injustice, poverty and war. Kollwitz's woodblocks and lithographs personalized and universalized human suffering in unprecedented ways. Kollwitz focused on the emotions of human faces and bodies in eloquent graphic works, images that are instantly recognizable as protests against injustice, poverty and war. She based her prints of starving and sick working-class Germans, especially women and children, on her first-hand observations in the slums of Berlin; they represent the wretched of any time and place. She also portrayed the sorrows of those who lost their fathers, husbands and children in war, as in her 1921 lithograph *Killed in Action*, which expresses the overwhelming grief of a mother and her children by using a few simple lines. Her lithographic poster *No More War* of 1924 became a *cri de coeur* for the pacifist movement that spread through Europe in the 1920s, the will of the people embodied in a single figure with raised arm.

1860s and then deserted him there. The French government prohibited the artist from exhibiting his painting and banned the engravings Manet made from the painting, not wishing the graphic images to make an already volatile situation worse for the government.

In the U.S., Thomas Nast attacked crooked politicians in New York. His series of caricatures, including the ingenious 1871 wood engraving *A Group of Vultures Waiting for the Storm to Blow Over—Let Us Prey*, satirized Boss Tweed and his Tammany Ring, corrupt officials who stole millions of dollars from the city. Nast's campaign against them led to Tweed's arrest and imprisonment.

Political printmaking had an even more important role in the early twentieth century. Prints became a pragmatic medium of political communication during the brutal upheaval of World War I and the

Another German Expressionist, Otto Dix, depicted the horrors of World War I in his series *Der Krieg (The War)*, a group of etchings with aquatint created from 1920 to 1924 that portrayed the carnage Dix had himself witnessed first-hand. The etchings have a savage directness

equaled only by Goya's prints of more than a century earlier. Like Goya, Dix showed the destruction and devastation of warfare stripped of all heroism. His images of decaying, decomposing bodies have a nightmarish quality that highlights the stark reality of trench warfare and its effects.

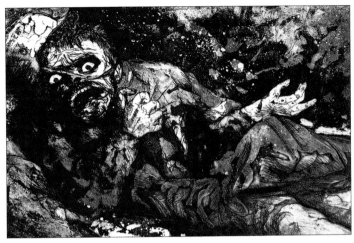

Otto Dix, *Wounded*, 1924
etching and aquatint

Dix's fellow artist George Grosz satirized the corrupt officers of the German army and their financial backers in images that match those of Goya in their relentless condemnation of social evil. In 1925, Grosz attacked Hitler directly, portraying him as a caveman with a swastika tattoo on his arm. Grosz and John Heartfield had developed the political photomontage around the end of the First World War, and after Hitler came to power, Heartfield began to use this medium to attack the activities of the Third Reich and to denounce anti-Semitism. Heartfield's 1934 montage *Blut und Eisen (Blood and Iron)* depicts four axes in the shape of a swastika, dripping blood. This powerful image, which became a sign of resistance in Germany, deconstructed and recontextualized the Nazi symbol and was widely distributed in underground publications and posted on walls. In the 1930s, Kollwitz, Dix, Grosz and Heartfield were all threatened by the Nazis and prevented from working openly in Germany. The Nazis confiscated the work of leftist artists from museums and dismissed them from their teaching positions. Images by Dix, Grosz and Heartfield were held up to ridicule in the *Entartete Kunst (Degenerate Art Exhibition)* of 1937, where millions of Germans were taught to mock modern art.

In that era, political imagery was a powerful force, for good or evil, and while the Nazis vilified all modern artists, leftist artists were in great danger. Kollwitz worked in semi-secrecy, Dix was imprisoned for a time, Heartfield fled to England and Grosz emigrated to the U.S.

Elsewhere during the 1920s, '30s, and '40s, artists created graphic work with revolutionary content in collaborative groups. After the Russian Revolution, artists used photomontage and woodcut to urge participation in the new revolutionary society. In the loosely organized Popular Front, formed in 1935, artists throughout the world focused their work on the evils of fascism. Even Picasso, not known for creating political content, responded to the growing violence with his monumental *Guernica*, which he painted after hearing of the bombing of the ancient Basque town of Guernica during the Spanish Civil War. On April 27, 1937, in collaboration with the forces of Franco, the Condor Legion of the German Luftwaffe attacked and destroyed Guernica, a civilian target, as a practice mission for their warplanes, soon to be used in World War II. On May Day, more than a million Parisians took to the streets

to protest, and Picasso began his dramatic painting of this crime against humanity. He achieved a sense of immediacy by combining semi-abstract black and white shapes with the graphic effect of newspaper print.

In the U.S., social realist artists formed organizations such as the Artists Union and the American Artists Congress, published their work in *Art Front*, and held print exhibitions that traveled around the country. Prints such as Louis Lozowick's 1936 *Lynching* (one of many on this subject) and William Gropper's *Miners* of 1935 addressed issues of racism and labor unrest.

In Mexico, collective associations of leftist artists like the Liga de Artistas y Escritores Revolucionarios (LEAR, League of Revolutionary Artists and Writers) and the Taller de Gráfica Popular (TGP, Popular Graphic Arts Workshop) produced high-quality woodcuts, linocuts and lithographs as illustrations for political events and activities. During the 1930s and '40s the TGP directed its efforts against fascism. The group created a number of images about Mexican fascism, the Spanish Civil War, and the rise of Hitler and Mussolini. In 1938, the TGP issued a series of powerful anti-Nazi posters that advertised lectures by leading intellectuals and scholars in Mexico City. The printmaker Leopoldo Méndez, a leading force in this print movement, made numerous anti-Nazi prints; his *Deportation to Death* of 1942, depicting a train bound for a concentration camp, is one of the first portrayals of the Holocaust by someone outside the camps. This print, and many others by members of the Taller, appeared in the book *El Libro Negro del Terror Nazi (The Black Book of Nazi Terror)*, a remarkable document of Nazi atrocities published in Mexico in 1943. Many printmakers from the U.S., Europe, and Latin America studied with the TGP in Mexico City.

In China, as in Mexico, printmakers began to use "art as a social weapon" (as Diego Rivera called it) to depict suffering and injustice and to express the artists' stands against fascism and imperialism. In the 1920s Lu Xun, the first Chinese author to write about poverty and oppression in China, started the Chinese Woodcut Movement, promoting woodcuts as a political medium for the nascent Chinese Revolution. He drew upon European and Japanese sources as well as Chinese folk art for inspiration and organized workshops and classes throughout China. Although the Mexican Revolution had already occurred and the Chinese Revolution had not yet taken place, Chinese and Mexican artists made their work in response to similar social conditions and political ideologies and worked with the same European influences. The work of Goya, Daumier, and Kollwitz, as well as Soviet prints of the 1920s and '30s especially inspired them. The work of Mexican artists of the Taller de Gráfica Popular reveals striking parallels to the prints of Chinese artists Cheng Tiegeng, Li Hua, and Li Qun, a similarity of style and content that can only be accounted for by a remarkable consonance of artistic and political concerns in the two countries. In fact, the prints of this period are so easily identifiable that even in the present, graphic work of this type functions as a sign of leftist political activity, indicating that, in the case of printmaking, political context became inextricably associated with artistic style and content. This connection persisted long after the historical movements that produced the original work.

After the Second World War and with the beginning of the Cold War, the role of political printmaking diminished dramatically. European and American artists, enamored with Abstract Expressionism, turned away

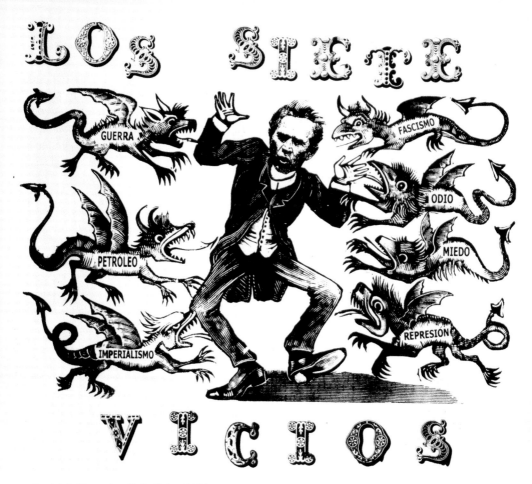

Patrick A. Piazza, *Los Siete Vicios*, 2004
screen print, 25" x 22.5"

from overt political content. Remarks by the critic Thomas Hess express the strong association between printmakers and the political image:

> Visiting galleries with Franz Kline around 1955, I asked him how he felt about making prints, perhaps lithographs, thinking that his vivid white and black image could be perfectly suited to the velvety inks and papers of the medium. "No," he said, "printmaking concerns social attitudes, you know—politics and a public...." "Politics?" "Yes, like the Mexicans in the 1930s; printmaking, multiplying, educating; I can't think about it; I'm

involved in the private image," (quoted in Huntington Gallery, *El Taller de Gráfica Popular: Block Prints and Lithographs by Artists of the TGP from the Archer M. Huntington Art Gallery.* Austin, Texas: Huntington Gallery, University of Texas, 1985, p. 9).

However, artists continued to make socially conscious images. Activists made prints and posters during the Civil Rights Movement and the Vietnam War in the U.S., in democracy movements worldwide, and in revolutionary Cuba and other Latin American countries. From the 1960s to the present many well-known artists have produced powerful political images. In the

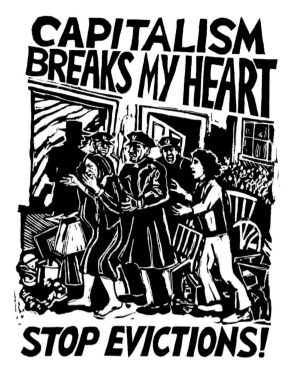

Sue Simensky Bietila, *Capitalism Breaks My Heart - Stop Evictions*, 2009
linocut, 11.25" x 15"

II, also made prints such as *Men Are Not for Burning* about the war. Sue Coe, another painter of political images, has created *Tragedy of War*, a cycle of twenty-three etchings on the theme of war, guns and violence at the end of the twentieth century. (Her print, *We're All in the Same Boat*, can be seen on page 40.)

Today, interest in graphic political art is on the upswing. Prints protesting war and oppression, in the form of posters, flyers and stencils, appear on the walls and streets and in newspapers and magazines. Racism, sexism, the World Trade Organization, the Gulf War, 9/11, the war in Iraq, and nuclear proliferation all elicit responses from politically engaged artists. Organizations such as the Center for the Study of Political Graphics promote and preserve politically motivated images. And *Paper Politics* artists from many countries, working in a variety of styles and mediums, have contributed 200 compelling images that expand on the enduring tradition of socially concerned printmaking, a tradition that will continue for as long as such images are needed.

1960s, Ed Kienholz's installations provided searing indictments of social conditions; for example his *State Hospital* is a nightmarish scene of the treatment of the mentally ill in America and *The Illegal Operation* is a chilling look at the issue of abortion before Roe v. Wade. While denying any interest in politics, Andy Warhol created the silkscreens *Red Race Riots,* of 1963, based on photographs of civil rights protesters in Birmingham, and *Electric Chair,* of 1971, a haunting image of the execution chamber at Sing Sing. African American artists have addressed issues of racism and sexism in graphic art, in such early works as Elizabeth Catlett's 1947 linocut *Sojourner Truth* and Alison Saar's 1999 *Washtub Blues*, or have celebrated African American life, as in Faith Ringgold's prints based on women's quilts of the late 1990s. Leon Golub, known for his paintings of the Vietnam War, such as his 1973 forty-foot long canvas *Vietnam*

Deborah Caplow teaches art history at the University of Washington. In 2007 she published *Leopoldo Méndez: Revolutionary Art and the Mexican Print* (University of Texas Press).

next page:
Alec Icky Dunn, *The Flood*, 2007
screen print, 18" x24"

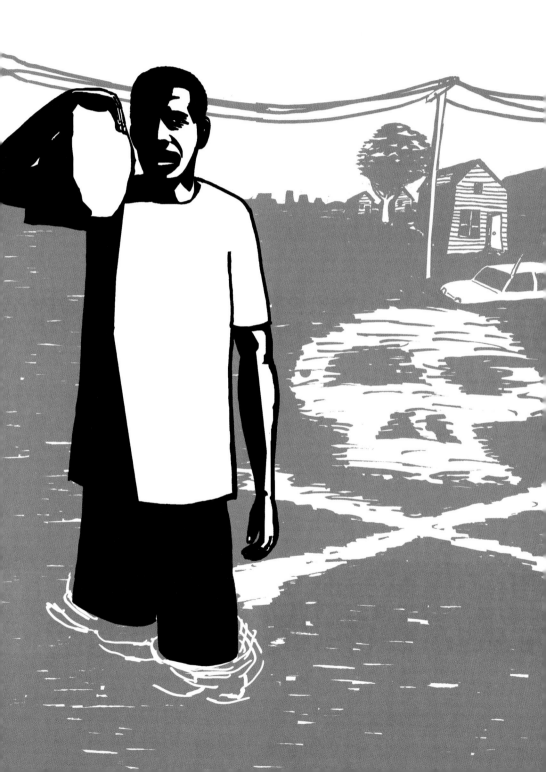

All the Instruments Agree

Eric Triantafillou

THE FAÇADE OF A NOW-DEFUNCT police station in San Francisco's Mission District is plastered with street art. It is a visual cacophony of posters, flyers, stencils, paintings, drawings, and the hand-scrawled responses of passers-by. A remnant of the housing struggles that began in 2000, today this wall is a public commons that transmits information about everything from legal rights workshops to communist party meetings and yoga classes; also occupying its surface are corporate ads cloaked in DIY lino-chic. It is also a screen onto which people project thoughts and feelings about the world they fear and visions of the one they want.

From a distance, all these competing images and ideas side by side create an uneasy harmony, like a Jackson Pollock painting—a kind of abstract social expressionism. Up close, reading the messages, you see a lot of contradiction and tension, evidence of the wall's messy and contentious evolution. The tactile beauty of the wall is immediate, and yet you realize that this wall is not just a space; it also reveals a history—it is a process in time. But what kind of process? Is the wall a representation of a public and participatory experiment, or its actualization? Is the wall a *truly* democratic space in a society that only claims to be democratic? Do these disparate images and contradictory ideas illustrate the diversity of our social, cultural, and political perspectives?

We could view this form of public communication not as constituting a consensus, but as proof that we can have *dissensus* and yet still coexist. After all, no one has to listen to or agree with anyone's opinions; they simply need to tolerate them being expressed. Any idea, any image, can simply be covered over by another, ad infinitum. We could celebrate the wall as a bastion of diversity and dissent, a toehold in a society whose public space is increasingly privatized and controlled. But we also have to recognize that the wall can represent a norm for controversy in a society that has not found a way to resolve its conflicts, a society that easily recuperates the meaning of experiments like these and then sells them back to us as aesthetic commodities.

The book you hold in your hands is also a kind of wall. At one time or another, many of the images in this book have appeared in public spaces across the U.S.

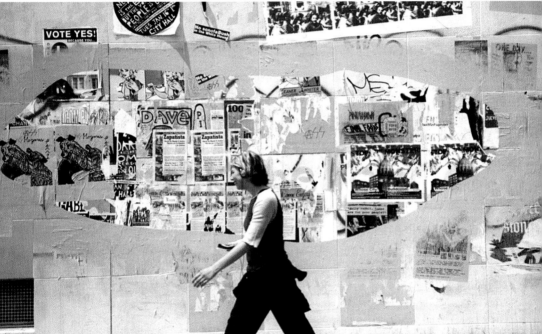

Wheatpaste wall on Valencia St., San Francisco, 2000 (top) and 2002 (bottom)
photographs by Eric Triantafillou

and other countries. Like layers of time, these images have been peeled off the palimpsest and placed next to each other on the page. These juxtapositions are both powerful and problematic. Like the wall in the Mission, this book represents a diverse cross-section of ideas and practices that together form a loose aggregate that we could call "left political art." However, viewing all these images next to each other can give the appearance of political unity when there may actually be none.

As printmakers, most of us produce our work with an understanding that we are contributing to and continuing the tradition of politicized printmaking that Deborah Caplow discusses in her essay—a tradition that began with Goya in the early nineteenth century. I often think that we

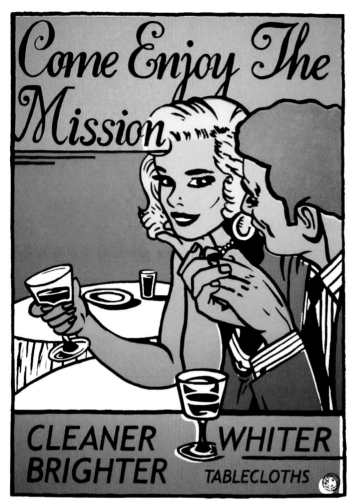

Eric Triantafillou, *Cleaner, Brighter, Whiter Tablecloths*, 2000
screen print, 19" x 25"

The graphic art of dissent over the past century and a half is an endlessly twisting, impossibly varied, and fantastically inspired and inspiring maze of imagery. Yet within this multiplicity of signs, symbols, and slogans there are clearly many that are used again and again. The images of past struggles comprise a kind of inventory of left visual tropes that are continuously recycled. New generations of makers adapt the images of previous generations to the social conditions and aesthetic sensibilities of the present. This is in part what it means to operate within a tradition. Images of the past are re-used in order to commemorate them, to create symbolic continuity, to inspire new social movements with the knowledge that they are rooted in the past, to prevent historical amnesia.

are more preoccupied with continuing this tradition than with asking why the promise it holds out—the promise of universal emancipation—remains so elusive. Our need to be constantly busy, to always be making more, is endemic to the activist compulsion to keep a movement alive, with little sense of what we are moving toward or why. I would go so far as to say that we, the producers of images that are meant to represent social conflict and its antidotes, may actually be complicit in prolonging, as opposed to fulfilling, this broken promise. How could this be?

Left graphics regularly portray the relationship of social forces as a conflict between two sides: *Us*—children crying, clenched fists, crowds amassing, plants growing, doves alighting—versus *Them*—bombs falling, smoke stacks spewing, barbed wire, prison bars, skeletons. In nineteenth-century France, left political cartoons frequently characterized the bourgeoisie as a parasite that sucks the blood of the workers. Many early anarchists and socialists believed that if the workers—whom they believed produced all the wealth—could rid society of the

bourgeoisie, they would finally be free. In the history of left political art, this opposition is played out again and again in expressions like "Capitalists need workers, but workers don't need capitalists." It is probable that in a society in which workers controlled production there would be a more equitable distribution of material wealth. But I don't think it helps to think of capitalism as something that some people *do* and others *don't*. We are all subjects of the same socioeconomic system. The captains of industry and finance are no less dominated by this system, regardless of the fact that they benefit more, than the billions of people with far less. We are all bound to a system characterized by a blind march toward profit, one that must constantly revolutionize or perish.

In early 2000, during the housing crisis in San Francisco that was caused by the new Internet economy, I produced the image *Cleaner, Brighter, Whiter Tablecloths*. An ironic jab at the hipsters who were moving into the neighborhood, it refers to the ethnic bleaching of the city's predominately lower-income Mission District. The image portrays the immediate reality that was visible in the streets, representing gentrification as an opposition between those perpetrating it and those fighting against it. Representing the "gentrifiers" makes it unnecessary to represent those fighting against gentrification; the latter are implied. If as a viewer I don't identify with what the symbols in the image signify, I am against *them*; I am one of *us*. And since we tend to affirm symbols of resistance as authentic expressions of suffering, joy, and indignation, we rarely question the thinking or the politics that are bound up with these symbols.

Cleaner, Brighter, Whiter Tablecloths only mirrored the way things appeared on the surface: young, white, urban professionals move into a "Latino" neighborhood, driving up real estate values and disrupting the sense of community. This conception reinforces the idea that capitalist society operates and can be understood through binaries like gentrifiers versus indigenous residents. What gets lost is the understanding of gentrification as a consequence of a socio-historical dynamic that shapes the actions of everyone involved: the venture capitalist who invests; the politician who frames the change as the natural course of economic development; the planning commission that rezones the neighborhood to pave the way; the banker who lends; the property owner who borrows to flip a condo or the first-time home-buyer who takes out a mortgage she can barely afford; the developer who controls the building trades or the independent contractor who hires cheap immigrant labor; and the community coalition attempting to get a temporary moratorium on the construction of market-rate housing so a few lower-income families can stay in their homes a little longer. The image of colonizing yuppies in search of authentic cultural interaction flattens this complex set of actors and interests into an easy-to-digest call to action. The more complex challenge of addressing gentrification and anti-gentrification struggles as systemic, as part of a process in which capital moves in and out of the built environment—the spatial component of capitalism's necessity to continuously accumulate and expand—is something these symbols cannot communicate, and, in fact, obfuscate.

What is driving capitalism's imperative to continuously accumulate value and increase that value? Is it old-fashioned human greed or something else? Why does gentrification specifically, and capitalism more generally, appear as a struggle

between two opposing sides? Exploitation and social conflict are real and ever-present. But the socio-historical dynamic that structures all relationships, a dynamic that has become increasingly abstract over time, is concealed when it is understood through simple oppositions. This dynamic is rooted in the contingency and symbiosis of all social forces, classes, and interests. To reduce it to a conflict between good and evil does not help explain how this dynamic mediates social life, its origins, or how it has changed over time.

If we continue to express our politics as either choosing to do good or choosing to do bad, we will continue to think of the problem as one of *being*, as something *in* us, and not as a relationship *between* us. Good decisions by good people do not alter this dynamic in any fundamental way. Our focus on the ethical or unethical character of capitalist development, expressed in symbols of altruism versus greed, implies a politics of technocracy (an increase in social services here, a tighter regulation there), but also has the effect of closing off possibilities for more radical politics. Reform that ameliorates immediate material conditions strengthens the dominant thinking that our socioeconomic system is fundamentally sound, that it just needs some tinkering around the edges.

What if our images could do more? What if they had the potential to be radical, to go to the root, to try to represent the relationship that is hidden behind the binary idioms of our tradition? What if we were able to know what determines, and to clearly express, that which is truly wrong with capitalist society? As negative as our thinking and our images might become, they would point toward what is right and better.

At the same time artists are working through problems of representation, we must also think about *how* we produce images. What are the contexts in which our images are made? Who are the images for? Are they just preaching to the converted? If *Cleaner, Brighter, Whiter Tablecloths* was problematic as an image, the context in which it was made—as part of a larger effort to mount a visual response to what was happening in San Francisco's Mission District—had far more potential. In 2000, some fellow printmakers and I began making posters about displacement and evictions. One of the places where we put them was on the old police station wall. Our group, the San Francisco Print Collective, became the propaganda wing of a neighborhood coalition that had come together to fight gentrification. SFPC members were united by the idea that art is an incredibly powerful tool when rooted in a social movement. We didn't always agree with the political positions or tactics the coalition adopted, but we shared a common goal. The SFPC's images and messages were composed by multiple voices within our collective, but when they hit the streets they spoke with one voice. Our work's constant visual presence in public space helped communicate to others what was happening in the neighborhood. It also inspired and motivated people in the movement, inextricably linking our effectiveness and longevity to the wider community's struggle.

Artists of the past organized large-scale unions and popular fronts in response to the social conditions of their time. Although these forms of organizing shouldn't be ruled out, they haven't materialized in the present. Many artists already work in small collectives, organizing themselves around shared affinities, social values, mutual support, and resource sharing. This doesn't

mean that as artists we automatically share a common political vision because of our backgrounds, a certain temperament, the media with which we work, or our relationship to other social actors and institutions. But what if we did? What if, instead of letting this book or the Mission District wall represent our differences—our pluralism—we began to work towards articulating a shared commonality?

I advocate that we, left printmakers, develop a set of shared goals, and use our powerful ability to intervene in public space, to create new ways of thinking and new meanings that refuse the dominant ones, and to develop tactics that can help us achieve those goals. The voices in this book and on that wall give the appearance of unity, of a unified opposition to capitalist society. But on closer examination, you can see fissures, fractures, and contradictions. If we began to organize ourselves, to create spaces for collective reflection and political education, I think we would find that ideologically we are very atomized, and that many of us would rather remain this way because the concept of unity (and all the past failed attempts at it) means a loss of individual freedom.

The collective articulation of a set of goals (which in and of itself would be an incredible undertaking) would necessitate an in-depth analysis of all the practices we're engaged in. It would mean that we would have to confront the fact that some ways of thinking and some practices are probably better than others, as instruments for achieving our goals. This doesn't mean it is wrong to make images that advocate that we "Support the troops, send the politicians to war" or "Knit for the revolution." But it does mean that if these are the kinds of stories we tell ourselves and we attempt to fashion a politics out of them, we may not be getting any closer to our goals. In their broadest sense, these goals would have to involve creating the social conditions in which someone's desire to make whatever she wants, to think and act as she sees fit—without being dominated by time, space or someone else—will have been gained for all.

The wall insists on an encounter. It wants to be used. But it is a space that gestures toward something beyond itself. It is not an end. It is a process of *becoming*. At the same time we create spaces of dialogue and public commons, at the same time we continue our tradition as the archaeologists of dreams and the farmers of inspiration, we can realize the force of unity that lies dormant in our fractured and individualistic practices. Let's investigate our own thinking. Let's look at our practices. Let's collectively reflect on the images we make, and how and for whom we make them. Let's ask if they could do more—if they could reveal the abstract barbarity of our social reality, and still incite and inspire us. As long as our goals are based on an intransigent desire for total social freedom, we have nothing to fear.

Eric Triantafillou lives in Chicago where he teaches and writes. He cofounded the San Francisco Print Collective and Mindbomb, a collaborative political activist art group in Romania.

repre

imprisonment
eviction
torture
surveillance
media control
privatization
apartheid
suppression

ssion

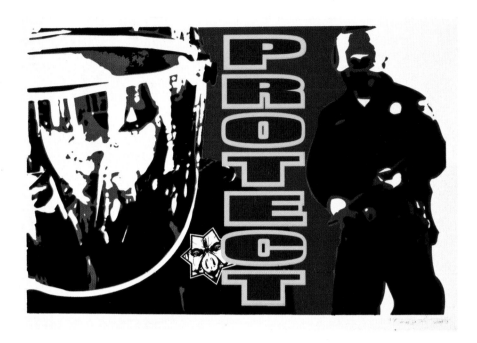

clockwise, from top:
Ryan J. Saari, *Protect*, 2007
screen print, 22" x 15"

MK 2003, *Bonzai*, 2003
screen print, 9" x 12"

Gabba Levtchenko, *Bad Neighborhood*, 2003
screen print, 15.5" x 25"

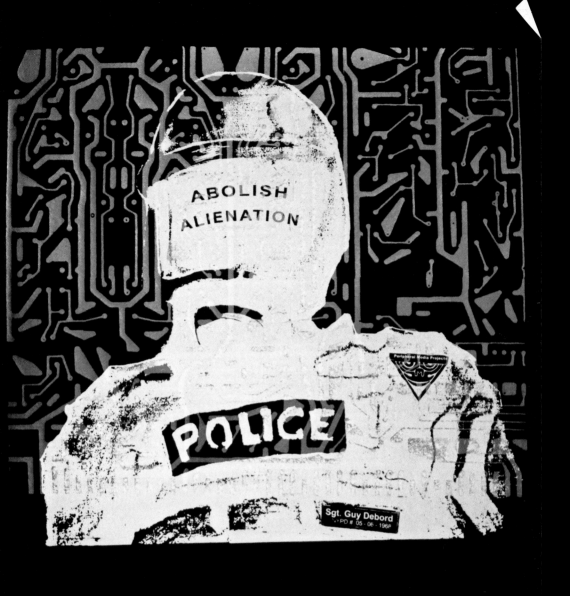

Peripheral Media Projects, *Abolish Alienation/*
Sgt. Guy Debord, 2003
screen print, 26" x 23.75"

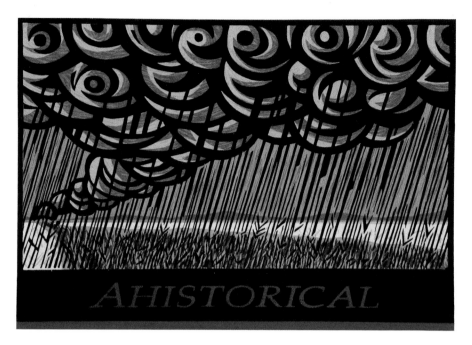

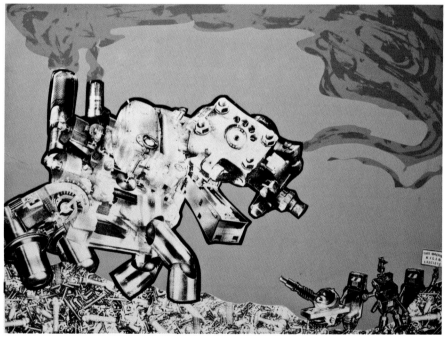

Endi Poskovic, *In the Western Land
(AHISTORICAL)*, 2004
woodcut, 18" x 15.5"

Nathan Meltz, *This Machine Kills Fascists*, 2007
screen print, 25" x 19"

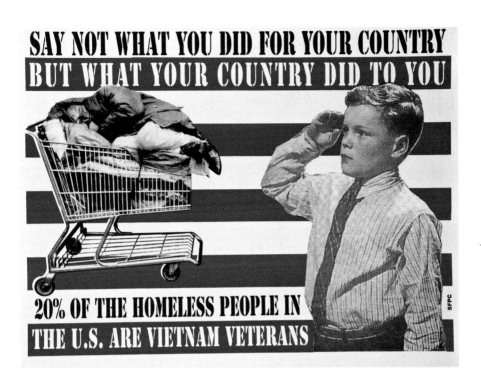

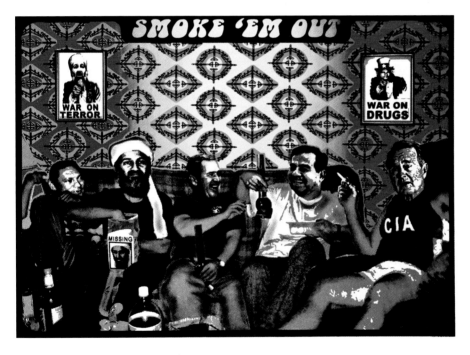

Csilla Kosa, *Say Not*, 2000
screen print, 23" x 18"

Goatskull, *Smoke 'em Out!*, 2003
screen print, 24" x 18"

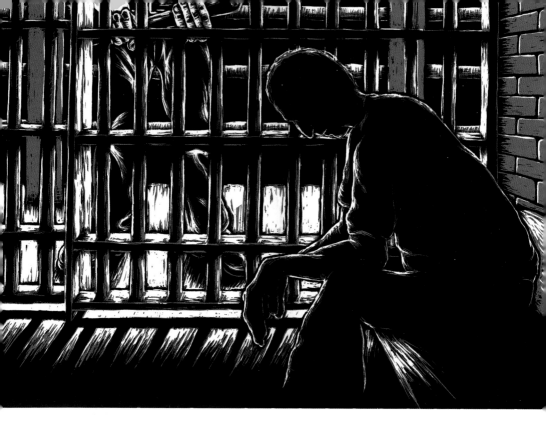

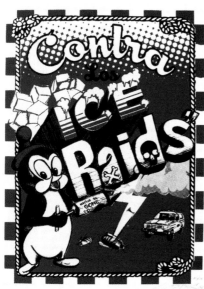

Xenios Zittis, *Behind the Prison Walls*, 2000
screen print, 16" x 11.5"

WERC, *Contra Los ICE Raids*, 2008
screen print, 20.25" x 26"

I HAVE A BODY, AND people have bodies, and people exist in real spaces and places. As long as we have real spaces and places, there is a need for real THINGS in those places that can communicate and lend meaning to what is going on around us. For now, handmade papers adhered to walls, stencils spray painted on concrete, and flyers stapled to telephone poles still resonate. Their relevance, however, will very much depend on the message. If a flyer on a pole is advertising for, say, The Gap, well, so what? Who really cares? But what if a screen printed paper is stapled to the same pole, with a message reading "Machines Make Babies Slaves" with a collage image of a baby suckling the teat of a giant petro-chemical-fueled mechanical monster? Well, now I care!

-Nathan Meltz

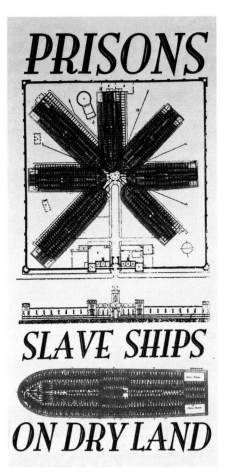

PRISONS

SLAVE SHIPS
ON DRY LAND

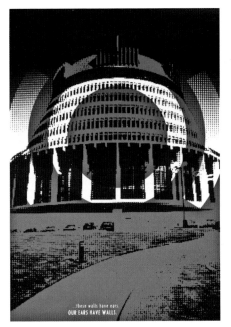

...these walls have ears.
OUR EARS HAVE WALLS.

PRISONS WILL NEVER PREVENT THE REASON FOR CRIME

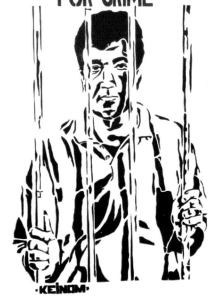

·KEINOM·

clockwise, from top left:
Andalusia Knoll, *Slave Ships on Dry Land*, 2003
screen print, 13" x 25"

Garage Collective, *Solidarity*, 2008
screen print, 17.25" x 25"

Nicholas Ganz (Keinom), *The Reason for Crime*, 2005
stencil, 17.25" x 29"

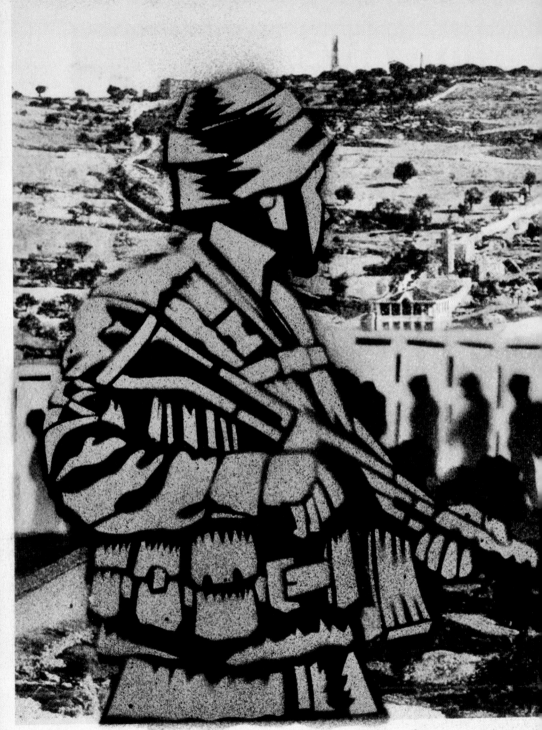

"Greetings"

JERUSALEM – Mont des Oliviers.
Mount of Olives. – Monte degli Olivi.

Christopher Cardinale, *Greetings from Palestine*, 2005
stencil & inkjet, 18″ x 13″

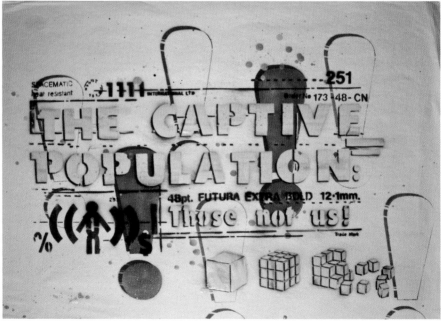

Emily Ann Pothast, *New American Mascot*, 2003
screen print, 11" x 7.5"

Tom Civil, *The Captive Population*, 2005
stencil, 23" x 33"

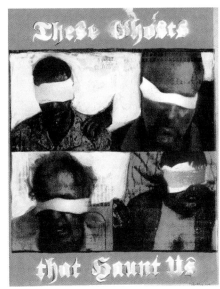

the hooded
prisoners
recognize
one another
by their
coughs

clockwise, from top left:
Stephen Melkisethian, *Protecting the Nations Capital From Photographers*, 2002
gelatin silver print, 11" x 14"

Tyler Kline, *These Ghosts that Haunt Us*, 2005
photocopy & stencil, 8.5" x 11"

Peg Grady, *Liberty*, 2004
lithograph, 11" x 17"

Dara Greenwald, *E. Galeano Has Seen this Before*, 2005
stencil, 18" x 19"

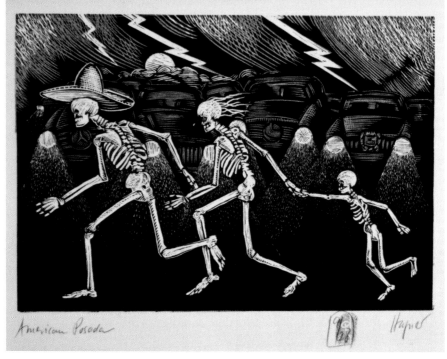

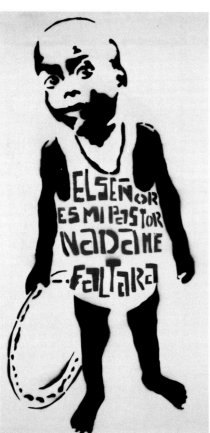

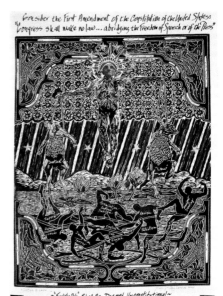

clockwise, from top:
Dirk Hagner, *American Posada*, 2002
engraving, 18" x 14.5"

Jim Larriva, *Justice vs. Law*, 2007
linocut, collage & colored pencil, 24" x 36.5"

BSAS Stencil, *El senor es mi pastor*, 2006
stencil, 21" x 38.5"

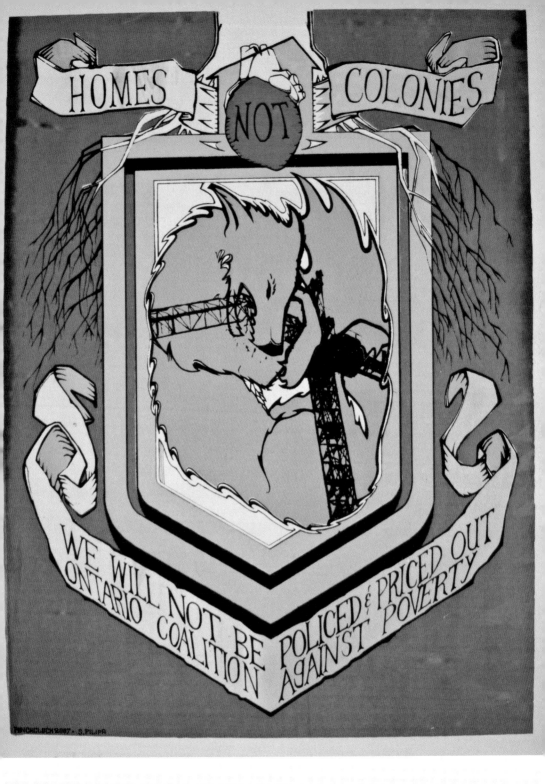

Stefan Pilipa, *OCAP Poster*, 2007
screen print, 22.5" x 30"

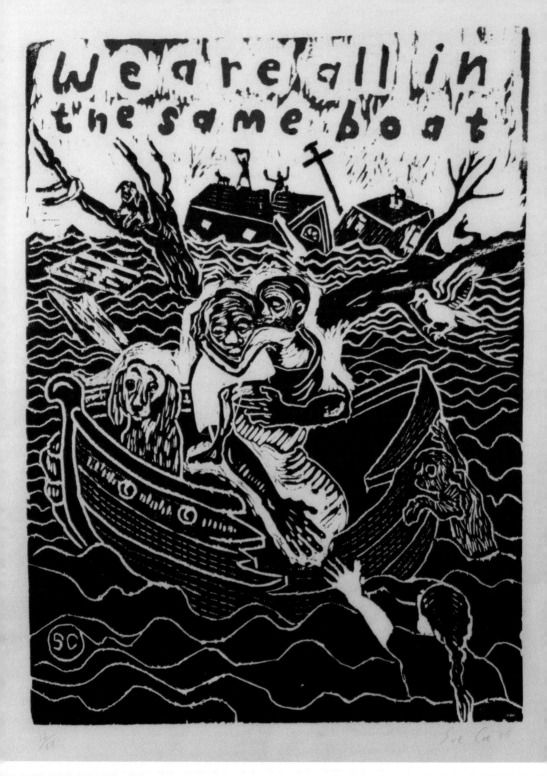

Sue Coe, *We are all in the Same Boat*, 2005
woodcut, 13" x 19"

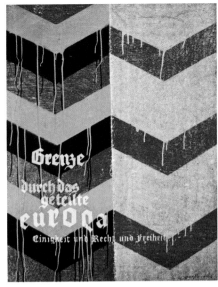
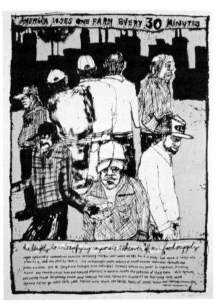
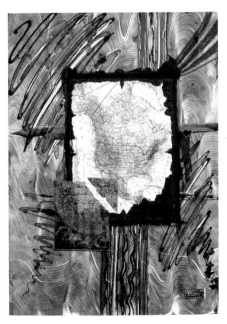

clockwise, from top left:

Jesse Purcell, *A.G.F.T.P.O.T.U.S.O.A. (a gift from the people of the united states of america)*, 2002
screen print, 22" x 29"

Nelson Crespo, *Grenze*, 2004-05
screen print, 22" x 27.75"

Sharri LaPierre, *Expansion*, 2004
monotype & collage, 22" x 30"

Colin Matthes, *Every 30 Minutes*, 2007
screen print, 19" x 25"

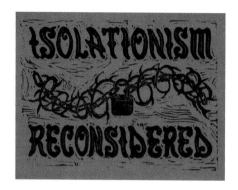

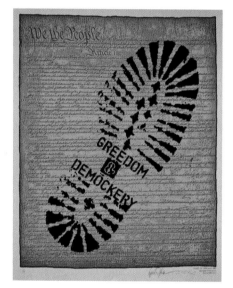

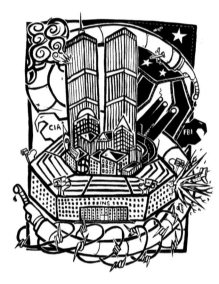

As a professor of Anthropology at Austin Community College, I tend to take an anthropological approach to photography. My subjects include the people and landscapes of many parts of the world as well as globalization and its effects on the lives of people in other places. I turn my photographs into fine art prints by making them into etchings using solar plates (polymer plates) and an intaglio press, which has been in use for centuries. The work is inherently ambiguous with a mysterious quality. We can find beauty in the exquisite, as well as the mundane.

−Carol Hayman

clockwise, from top left:
Bert Stabler, *Isolationism Reconsidered*, 2005
linocut, 13" x 11"

Carol Hayman, *The Disappeared*, 2004
solar plate intaglio, 10" x 8"

Jon Paul Bail, *Untitled*, 2004
screen print, 21.5" x 30"

Emek, *Bootprint (Greedom & Demockery)*, 2004
screen print, 21" x 26.25"

opposite page:
Chris Stain, *Winter in America*, 2006
stencil, 13.5" x 22.25"

When I'm cutting out stencils I'm resisting the machine. It's me, a blade, and a sheet of paper. When I hold two prints side by side, each will have its own personal characteristics. I love it. I love the under- and over-spray, the drips and all the raw elements that are created.

It's valuable to me that I have time in my studio to cut out stencils; this is when I can meditate and think about the world around me. I enjoy creating new art work. I can give people something they have never seen before.

–Mathew Curran

Gabriel Cohen, *Send One To Get One (1, 2, 3)*, 2008
screen print, 5" x 7"

As THE MASSES JUMP ON trend after soul-numb-ing trend speeding blindly headfirst off of Internet & advertising cliffs to immediate-ly forgotten pits of nowhere, it's important to be reminded to slow down. Making and seeing handmade art are poetic, necessary reminders of human energy and of political and personal expression. Stenciling (and postering in my case) is artistic communi-cation that can cheaply spread images and messages. It is hands on, real work. It's af-fordable to make, anywhere, anytime, with few materials. You don't need an expensive computer, printer and inks. You don't need a copy shop or a big box store. By sten-ciling you can easily repeat your image/message. With only your imagination and some spray paint, you can communicate to strangers on the street through the power of your handmade images.

Putting handmade art out for free (or cheap) also helps to counterbalance the insanity of the inflated elitist Art World prices that perpetuate a hypocritical sys-tem emphasizing money, greed, and ma-terialism more than real, soulful art and its priceless value, its capacity to enlighten and connect humanity. Artists themselves must take responsibility for breaking down this system. Small batch printmaking and stenciling are beautiful, efficient, cheap methods of making art that are do-able and attainable for all. I've taught folks of all ages and backgrounds the techniques of stenciling and postering, and it's glori-ous to watch their eyes and minds light up! Make prints and GO!

-Sam Sebren

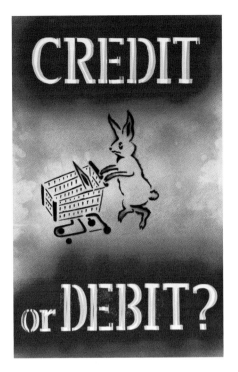

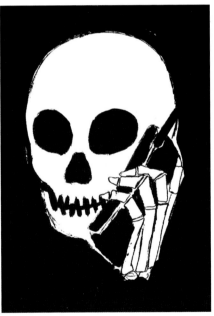

Sam Sebren, *Breeding Zombie Consumer*, 2008 stencil & paper cut, 14" x 22"

Spazmat, *Skullphone*, 2004 screen print, 22" x 16"

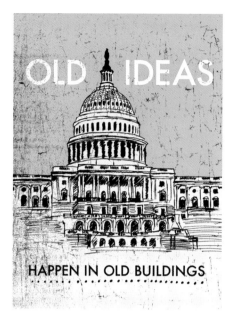

OLD IDEAS

HAPPEN IN OLD BUILDINGS

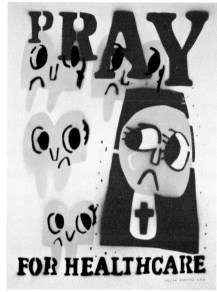

PRAY

FOR HEALTHCARE

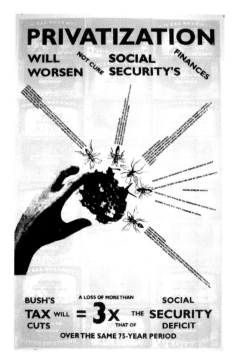

PRIVATIZATION

WILL NOT CURE SOCIAL FINANCES
WORSEN SECURITY'S

BUSH'S
TAX WILL = **3x** THE SOCIAL
CUTS THAT OF SECURITY
DEFICIT
OVER THE SAME 75-YEAR PERIOD

A LOSS OF MORE THAN

clockwise, from top left:
Chris Rubino, *Old Ideas Happen In Old Build-
ings*, 2004
screen print, 18" x 24"

Melina Rodrigo, *Pray for Health Care*, 2005
stencil, 22" x 28"

Mathew Curran, *Untitled*, 2005
stencil, 21" x 27"

Katie Burkart, *Untitled*, 2005
screen print, 11" x 17"

previous page spread:
Nat Swope, *Homeland Security*, 2005
screen print, 11" x 8.5"

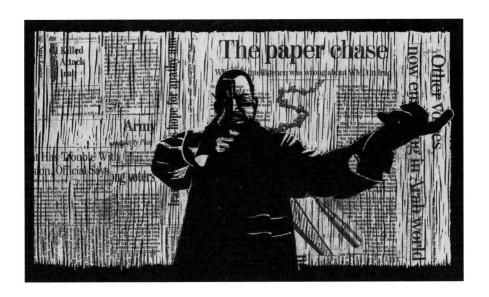

clockwise, from top:
Erin Hall, *PaperChase*, 2003
screen print & linocut, 14.25" x 19.5"

Valerie Roybal, *Prey Upon*, 2003
polymer gravure & screen print, 10.5" x 14.5"

Melba Abela, *Killing the Night*, 2004
etching, 11" x 15"

I MAKE PRINTS BY HAND because it's a cheap, accessible and participatory way to compete with corporate and government propaganda. Not content with controlling our bodies on the job, corporations have been trying to take over our "non-working" lives at home and in the streets. Advertising saturates our cities and dictates how we think so that any anti-capitalist alternative seems ridiculous and delusional. To make matters worse, I live in a high-priced, yuppie city where public space is dominated by real estate developers, banks, big landlords, and cops. Hand-made, silkscreen prints are a way to talk back and carve out a voice for myself and my community. Silkscreen prints also help the little people (low-income, housing justice and immigrant rights groups) take public space back from the Goliaths and put forth our own vision for the city's development.

Hand-made, silkscreen prints are really cheap for small runs (under 1,000) so the medium is well suited to making picket signs, media props and neighborhood-wide posters. Silkscreen also has a really fast production time, allowing for immediate responses to a quickly changing crisis or a fast-paced campaign. Since the technique is easy to learn, people with little or no artistic experience can represent themselves and make really powerful work. Silkscreen allows lots of people to participate in the production and distribution of a print. The more minds that are involved, the stronger

IF VIETNAM WERE NOW
WHAT WOULD YOU SEE?

the work becomes. With control of production in the hands of the creators, the process is also very empowering, a good example of unalienated labor.

I'll use any art medium if it's effective for an organizing campaign. More so than any other medium I've used, silkscreen printing has the best potential to be closely connected to and easily embraced by social justice movements. The only way things will get better is if we build stronger, more effective, and larger movements. My prints act like guerrilla PR generating publicity and power for low-income activist groups. These guerrilla prints use readily available resources, audacity, and improvisation to flip the weight of the system against

itself. If my prints are good, they should help union or neighborhood struggles in a strategic way, by publicizing a campaign, exposing corrupt politicians, winning new members, getting more media, or winning local reforms. If my prints are really good, they should clearly break down a complex issue and make you go through an ideological shift.

–Claude Moller

left:
Arthur Desmarteaux, *Our Father in Heaven*, 2006
screen print, 22" x 34"

right:
Claude Moller, *If Vietnam Were Now*, 2004
screen print, 20" x 15"

aggre

war
bombing
colonization
invasion
murder
extinction
genocide
rape

ssion

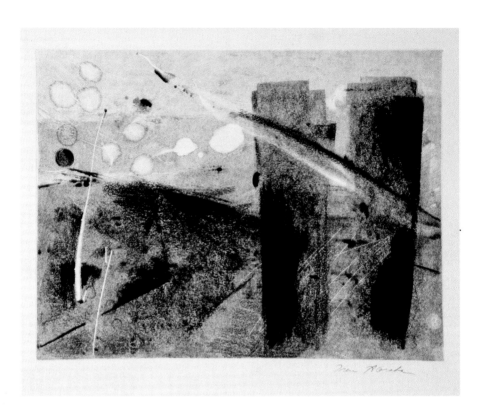

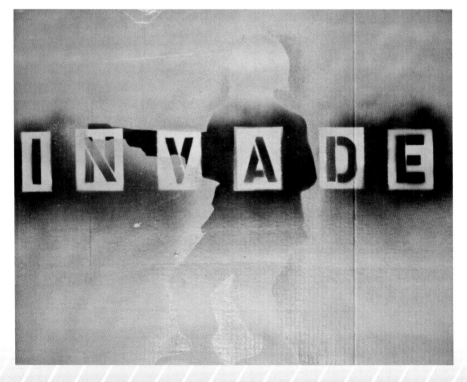

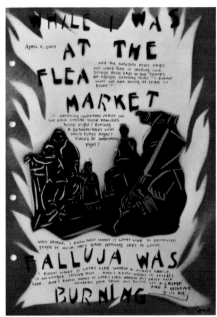

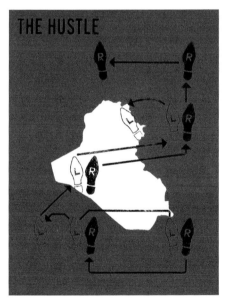

clockwise, from top left:
Rebecca Johnson, *McDubya*, 2004
screen print, 16" x 22"

etta cetera, *Fallujah was Burning*, 2004
stencil & calligraphy, 11" x 17"

James Dodd, *Metal Militia*, 2003
stencil, 11.5" x 16.5"

Jimm Lasser, *The Hustle*, 2004
screen print, 23" x 29"

previous page:
Irene Abraham, *Fear and Awe*, 2001
monotype, 12" x 9"

John Fekner & Don Leicht, *Invade*, 2006
stencil, 31" x 24"

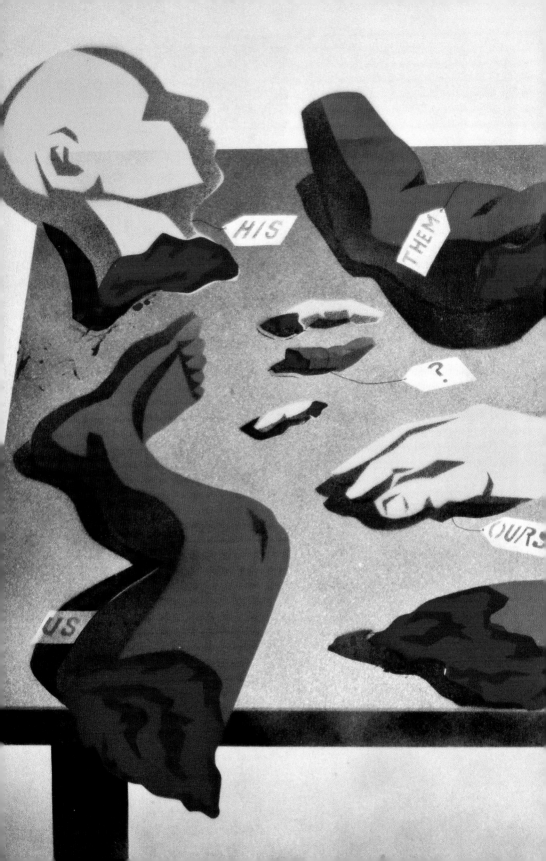

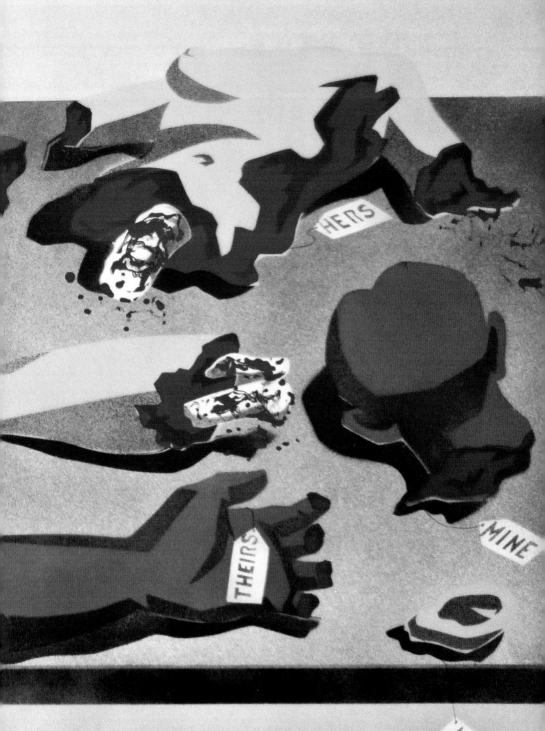

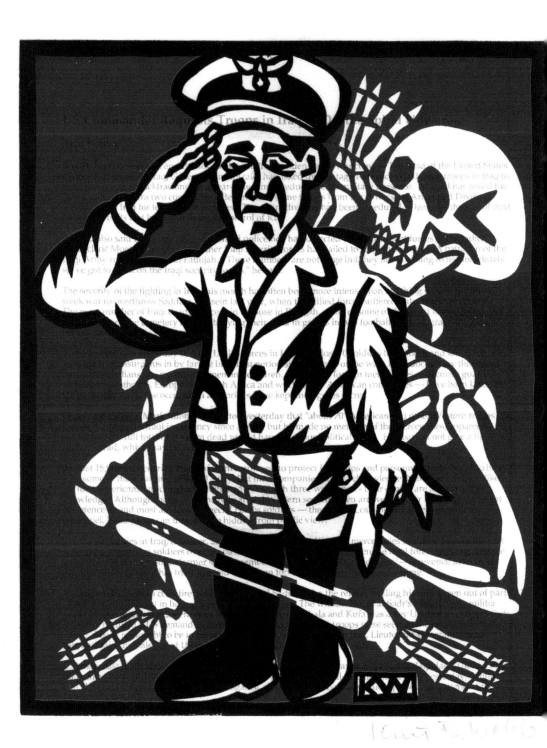

previous page spread:
Dave Loewenstein, *Sorting Out Iraq*, 2005
stencil, 28" x 22"

Kurt Brian Webb, *(Horn Playing Corporal)*
Veterans unveil Iraq War memorial wall, 2004
woodcut, 10.25" x 12.25"

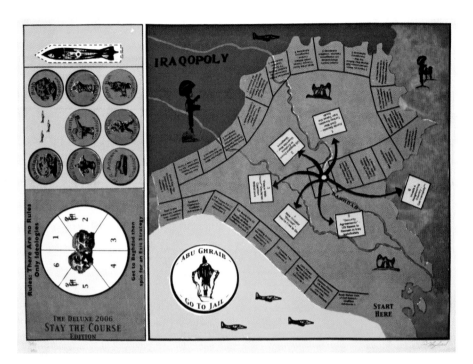

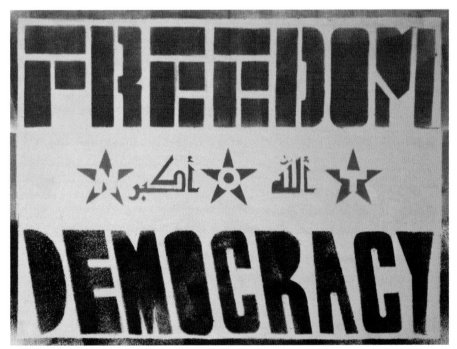

Art Hazelwood, *Iraqopoly*, 2006
screen print, 30" x 22.25"

Kevin Caplicki, *Self-Determination*, 2005
stencil, 18" x 13.5"

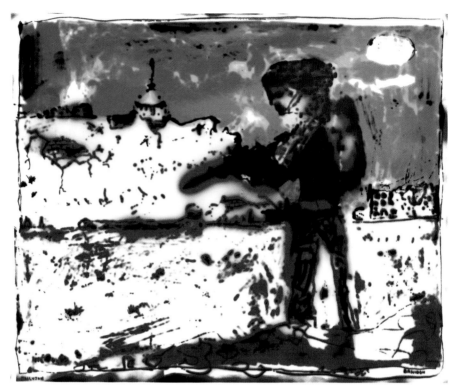

THE FALLUJAH PRINT SERIES WAS a culmination of a number of threads of ideas that all seemed to come together in a specific way within that work. I do not necessarily consider myself a printmaker, but I have explored printmaking, print and transfer processes, stenciling, and ideas about multiples in my art-making for over a decade. At the time I was exploring multiples in a number of different ways, responding to the idea that the use of multiples in art making is an egalitarian or democratic practice. I was exploring multiples with flyers and stickers opposing the war and the policies of the Bush administration that were placed directly on the street, and in my mixed-media work I was exploring "unique multiples"—creating a series of images with the same elements, but each one still an individual. The Fallujah print also came out of my interest in the creative possibilities of obsolete technologies. With digital photography and printing rapidly advancing, new forms were quickly replacing the old color darkroom chemical processes. I started exploring the chemical process of color photo-printing as a printmaking form, and had an earlier print experiment with this process included in the first *Paper Politics* exhibition in Chicago. I would paint on a piece of glass and use that painting as the negative to make a contact print. It was a very difficult process, especially thinking of painting in negative to get the right positive colors in the print, but an eerie, beautiful glow was achieved through the slow burn of the light through the painted negative. After hearing the apocalyptic reports from the Battle of Fallujah and the reports of the use of white phosphorus, that acid burn and glow seemed a perfect technique to use to create a piece in response to the events in Fallujah.

-Brandon Bauer

clockwise, from top:
Janette K. Hopper, *Face War*, 2005
linocut, 29" x 24"

Holi, *Woman in War*, 2004
stencil, 19" x 15"

previous page:
Brandon Bauer, *Fallujah*, 2004
photo processed print, 24" x 20"

Kyle Goen, *War Crimes Seal*, 2007
screen print, 27.5" x 33"

Mike Stephens, *Bear Market*, 2003
woodcut, 20" x 24"

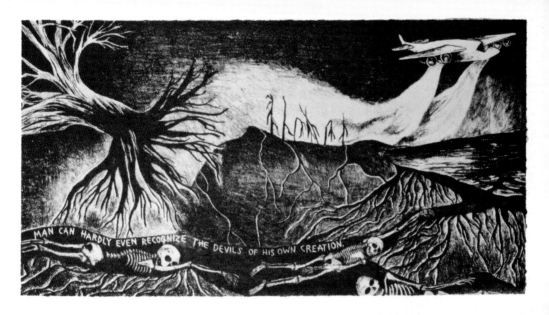

Man has lost the capacity to foresee and to forestall. He will end by destroying the earth. ---Albert Schweitzer

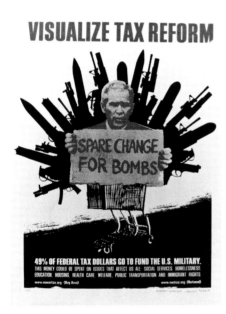

clockwise, from top:
Lydia Crumbley, *Untitled*, 2004
lithograph, 15" x 8"

Joshua Pablo Rosenstock, *It Was A Very Good
Year*, 2003
stencil, 12.5" x 19"

Alfonso Jaramillo & Marcela Reyes, *Spare
Change for Bombs*, 2006
screen print, 18" x 24"

I HAVE BEEN THE ART director of Dragon Dance Theatre since 1976, and have been printing for over thirty years. Katah joined me almost a decade ago and has become our printer. We have lived most of our lives in the U.S. and Canada, and we do most of our printing at Atelier Presse Papier in Trois Rivières, Québec, but we have travelled extensively throughout the Americas, and in northern, western, and central Europe. We are living and working as contemporary *artists engagés*, expressing our ideas and feelings through images representing what we see and feel in our human, social, physical, and political environment. Theatre, painting, and graphic arts are the principal modes of expression that we use.

In this area of political imaging we prefer relief prints, sometimes on masonite or wood, but usually on linoleum, which is generally available and not too expensive. We appreciate the possibility of printing our images with a wooden spoon. We don't usually do this, but we used to and sometimes we still do. Relief printing offers the possibility of making multiple images in the most remote places with limited materials, completely by hand. Another aspect of linoleum that we like is its sensitivity. It takes an impression of our feelings, our emotional state, and our mood, along with the graphic design. We like this personalization of the image.

In this age of electronics, people often ask why we continue to press paper onto an inky matrix, when a clean and odorless digital option is available? We have worked in this medium for many years, and because of that we have developed a certain level of skill in dealing with it. Slowly, the printer's secrets have been revealed to us. We know the qualities of the various linoleums that are available; we know the simple tools and how to use them, we have

our ideas about inks and papers. We know the history of the medium and the works of other artists who have used these same materials. We know better and better how to distribute our images.

Over the years we have made many images about events while they were happening. We engrave our images in response to the events we see in the world and we imagine that we will be able to communicate with our fellow humans using these images. This way of responding to current events gives us a sense of participation, even though the relationship might not always meet our expectations. In order to communicate with many people at once, we have tried various approaches, such as pasting our images on the walls of Montreal, or mailing them to our friends and asking that the images be forwarded and shared. Occasionally we send images out by email and ask our friends to print the images and post them. Sometimes they do. We have found that reaching out with our graphic ideas in exhibitions like **Paper Politics** can also be successful.

In March 2009, our image, *Stop Bombing Gaza*, was published in *Le Monde Diplomatique*, in France. Perhaps this has been the single most successful transition from expression to communication: sending the image by email to France, waiting a month for the printing and distribution and then very rapidly reaching a lot of people while the event was still fresh in everyone's mind. This was very satisfying and gave us a sense of actually participating in the formation of a public point of view. Suddenly we had a forum, and our perspective was included in the public discussion.

–Sam Kerson

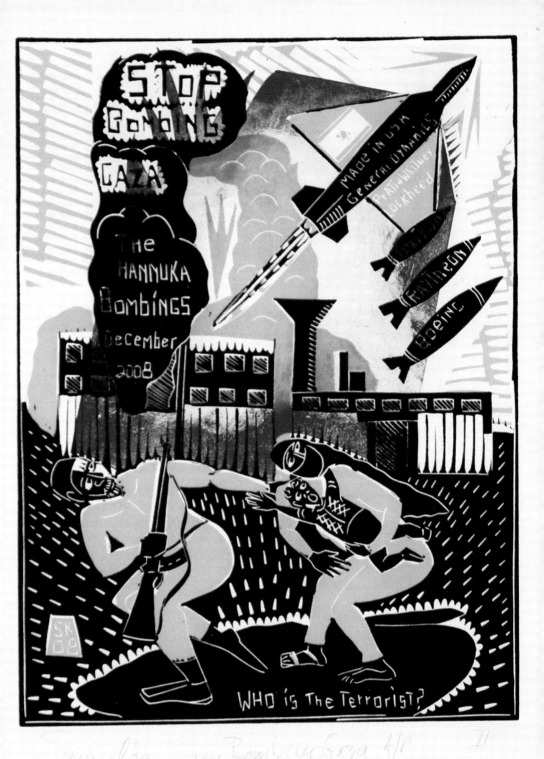

Dragon Dance Theatre, *Stop Bombing Gaza*, 2009
linocut, 13" x 20"

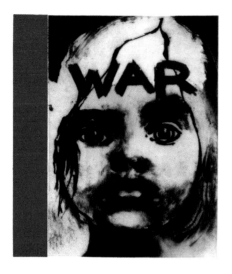

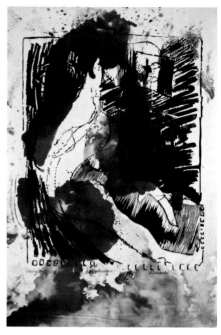

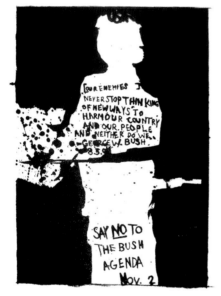

I HAVE BEEN MAKING LINOLEUM prints by hand for twenty-five years. The time it takes to carve a meticulous design is my time for self-reflection, meditation, and healing. It is precious time for me to be in silence and solitude. I enjoy thinking with my hands and handling different textures, from knives, pencils, and erasers to the slippery paint I roll out on glass plates. After this long and tedious process, the print that emerges is a special reward.

-Elka Kazmierczak

clockwise, from top:
Layne Kleinart, *9/11*, 2001
intaglio & relief print, 11" x 15"

Elzbieta (Elka) Kazmierczak, *Obalisque Violated*, 2003
linocut, 26" x 30"

Sara Lozito, *Not Again*, 2004
lithograph, 7.5" x 10.5"

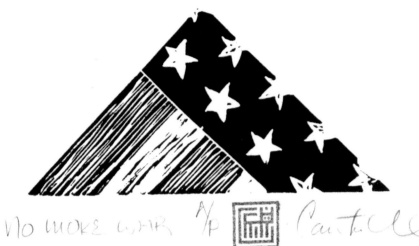

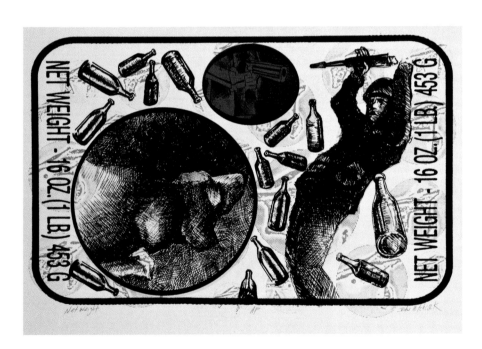

Daniel Cautrell, *No More War*, 2002
linocut, 10" x 8"

John Hitchcock, *Net Weight*, 2003
screen print, 20" x 15"

Dusty Herbig, *Untitled*, 2005
screen print & embossing, 15" x 20.25"

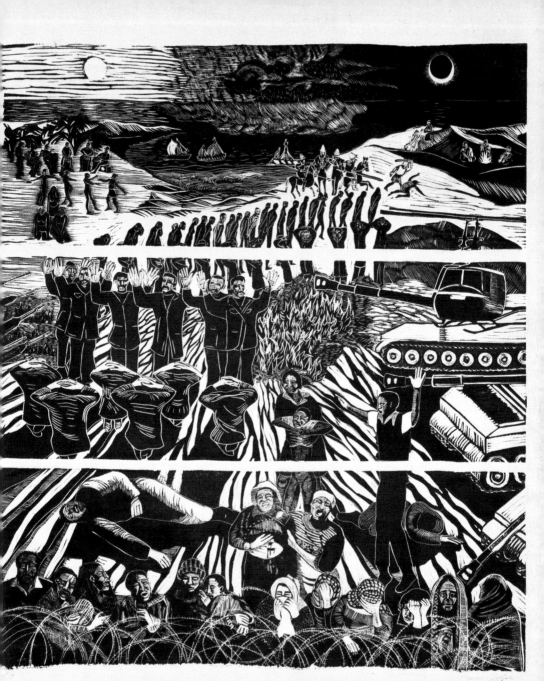

Alejandra Delfin, *Colonization*, 2008
relief print, 24.5″ x 26.5″

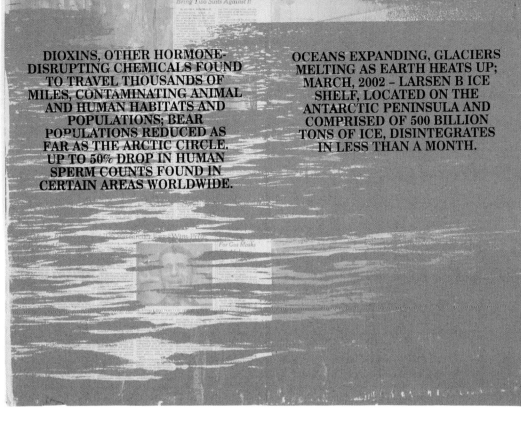

DIOXINS, OTHER HORMONE-DISRUPTING CHEMICALS FOUND TO TRAVEL THOUSANDS OF MILES, CONTAMINATING ANIMAL AND HUMAN HABITATS AND POPULATIONS; BEAR POPULATIONS REDUCED AS FAR AS THE ARCTIC CIRCLE. UP TO 50% DROP IN HUMAN SPERM COUNTS FOUND IN CERTAIN AREAS WORLDWIDE.

OCEANS EXPANDING, GLACIERS MELTING AS EARTH HEATS UP; MARCH, 2002 – LARSEN B ICE SHELF, LOCATED ON THE ANTARCTIC PENINSULA AND COMPRISED OF 500 BILLION TONS OF ICE, DISINTEGRATES IN LESS THAN A MONTH.

FOR THE PAST DECADE AND a half I've been producing limited edition books and prints. I work with found materials, altering old books, documents, and everyday objects to create new and disturbing meanings. (The piece shown here, *Current Events*, is an altered edition of *The New York Times*, which I overprinted with my own hand-silkscreened headlines that relate to environmental crises.) Everything that I do involves outmoded and antiquated processes—hand printing, hand binding, setting metal type letter by letter—and many people have asked me, "Why?"

The answer goes to the very root of why I make things. For me, art isn't about expediency, about doing something as quickly as I can. It's the opposite of that: it's a process of living in my studio with materials that hold great interest for me and mulling over my subject matter for months, until I know what I want to do and say. It's not uncommon for me to spend years on a project, and the techniques that I use—all of which demand much of me, but give back equally in terms of richness and beauty—mirror that intense involvement.

There is also an element in my work of connecting with the past, which has real spiritual meaning for me. A curator who once visited my studio pointed to a nineteenth century cotton trader's ledger that I had overprinted with slave narratives (a project titled *Accounts*). She asked me if that work would be the same if I had photocopied it, and I immediately replied, "No." I went on to explain that using materials that had been handled by people long dead was intrinsic to my work, a form of connecting directly to the past. In other cultures, people would refer to this as "speaking to the ancestors." We don't have those words or ideas in this culture, but I believe we still have the need.

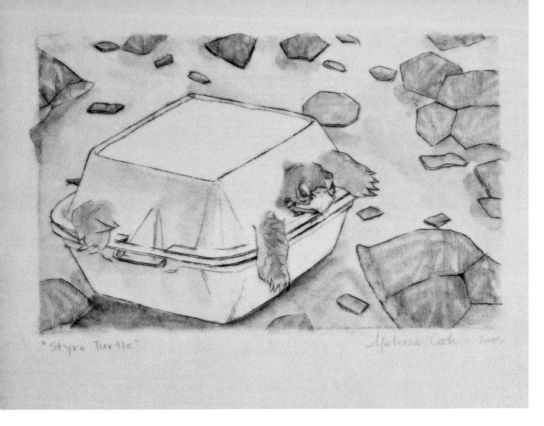

"Styro Turtle" Melissa Cooke 2005

Another need that we have is to work with our hands and our bodies—that's one of the things that makes us human, that's in our cellular memory. There's a satisfaction to working with one's hands as an artist, to exploring materials and building a relationship with them, that just doesn't occur with new media. I have so many students who come to me now and say, "I just want to use my hands, to hold a pair of scissors and cut paper."

Of course, in my own work, I often use methods that go beyond the experience of satisfaction and become painstaking. This feels right for my particular work, which involves uncovering first-person narratives and bringing them to light, a process that I sometimes refer to as "collaborating with the dead." Often these stories are painfully brutal ones that reveal something about our past and about who we are today. Using techniques that demand that I work hard, that are painstaking, is a way of entering into, and honoring, the experience of that person whose story I'm telling. Art is a mythic and magical process, one that must demand something of the artist, if it's to have a transformative effect on the viewer.

-Maureen Cummins

left:
Maureen Cummins, *Current Events*, 2001
screen print, 22" x 13"

right:
Melissa Cooke, *Styro-Turtle*, 2005
engraving & watercolor, 10" x 7.75"

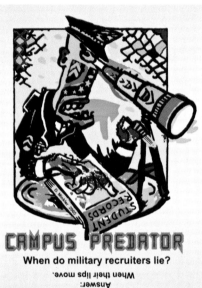

CAMPUS PREDATOR

When do military recruiters lie?

Answer:
When their lips move.

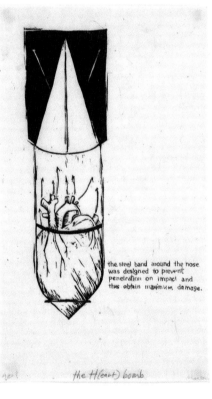

the steel band around the nose was designed to prevent penetration on impact and thus obtain maximum damage.

the H(eart) bomb

clockwise, from top:
Erik Siador, *Monkey's On Our Back*, 2003
screen print, 30" x 12"

Kari Hanson Couture, *H(eart) Bomb*, 2004
screen print, 8" x 14"

Larry Sommers, *Baghdad Postcard*, 2004
screen print & stamps, 7" x 5"

Doug Minkler, *Campus Predator*, 2005
screen print, 17.75" x 23"

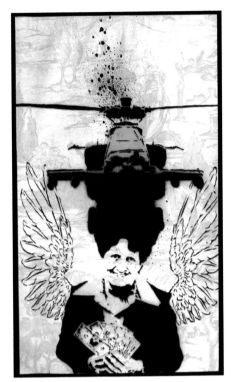

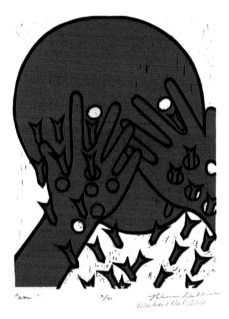

clockwise, from top left:
Tom Davie, *Piece of Meat*, 2003
screen print, 15" x 22"

Klutch, *Amerikana*, 2005
stencil, 13" x 21"

Patricia Dahlman, *WAR*, 2004
woodcut, 9" x 11"

Rorshach, *Victim of Changes*, 2006
stencil, 15" x 10"

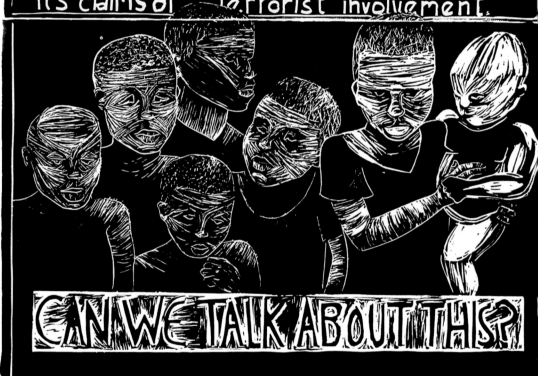

On August 20 1998 the US bombed the al Shifa Pharmaceutical Factory in Sudan. The factory produced approximately 50% of all Sudan's medicine. Sanctions have made it impossible for Sudan to import an adequate amount of medical supplies. Independent sources have estimated the death toll to number in the tens of thousands. The US government still has not substantiated its claims of terrorist involvement.

CAN WE TALK ABOUT THIS?

Emily O'Leary, *Can We Talk About This?*, 2003
linocut, 18" x 24"

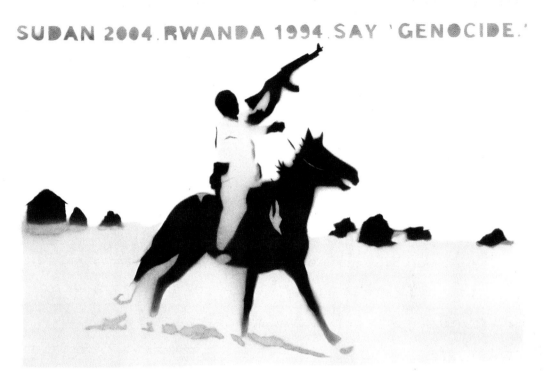

MY ETCHINGS PRESENT SPECTERS FROM other times that mediate in contemporary political and personal contexts. Using only intaglio and drypoint, I reanimate the detail of Old Master prints, while examining the sexual and social themes of the present. Each piece presents a specific narrative, with images woven together from modern media and classic representations. Many of my prints investigate issues of healthcare, such as AIDS, Hansen's disease, aging, gynecological surgery, and abortion. Other pieces explore my experiences of uprisings in other countries in which ritual practice helped defeat modern dictatorship—a paradigm in which fantastic or bizarre imaginings may thwart the thrust of the Religious Right in our own cultural wars. Juxtaposing imagery from a myriad set of sources, each of my etchings explores the relationship between self, myth and history. My etching **Desecration** conflates imagery from Cambodia and Vietnam to address the "American war," which killed two million Vietnamese. But no genocide is complete without the corresponding assault on culture. The napalmed little girl assumes aspects of a martyred Goddess, framed in the ruins of *The Churning of the Milk* from Angkor Wat, Cambodia. Why do I still etch, when I could just use the Internet, Twitter and YouTube? MY RAGE is inscribed line by obsessive line in a matter that is as lasting as the history it depicts.

–Reynolds

this page:
Beth Gutelius, *Darfur*, 2004
stencil, 17" x 11"

next page spread:
Reynolds, *Desecration*, 1984
etching, 24" x 19"

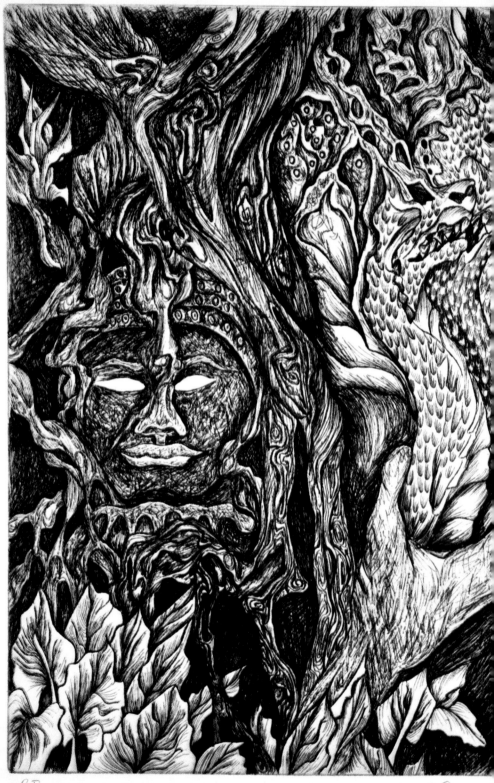

A.P. "Desert

this page:
John Carr, *U Been Served*, 2004–05
screen print, 18" x 14"

Alex Lilly, *United We Stand*, 2003
screen print, 24.25" x 21.5"

previous page:
Deborah Harris, *WAR*, 2004
woodcut, 6" x 8"

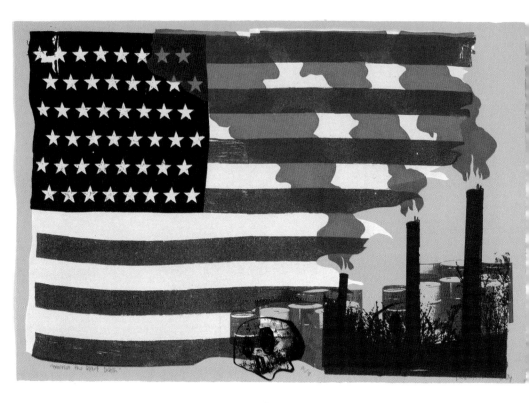

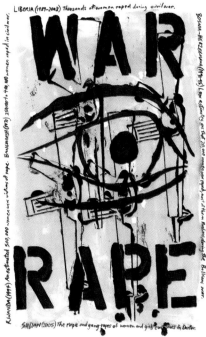

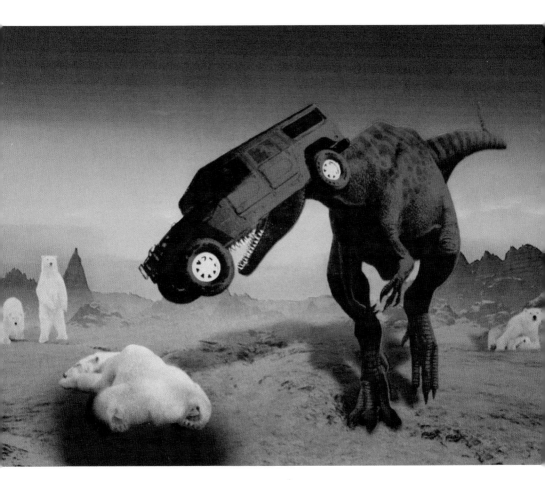

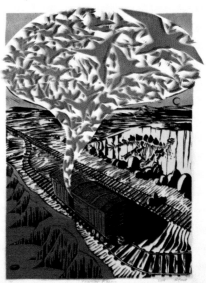

this page:
Karen Fiorito, *Hummersaurus Wrecks*, 2008
screen print, 28" x 22.5"

Roger Peet, *Passenger Pigeons*, 2008
linocut & stencil, 15" x 20"

previous page, clockwise from top:
Randal O. Hutchinson, *America the Black
Death*, 2004
screen print, 22" x 15"

David Lester, *War Rape*, 2004
stencil, 14" x 20"

Kathryn Glowen, *Darwinian Dilemma*, 2004
intaglio, 22" x 30"

resist

liberation
solidarity
organizing
occupation
direct action
uprising
disobedience
struggle

tance

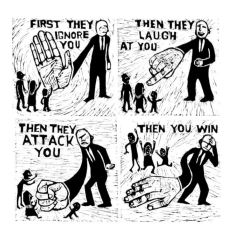

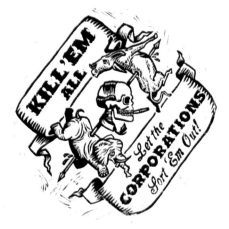

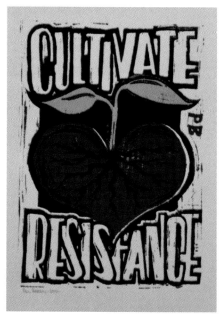

clockwise, from top left:
Jesse Graves, *Join*, 2009
linocut, 15" x 11.75"

Morgan Andrews, *Gandhi Quote*, 2001
linocut, 30" x 30"

Paul Barron, *Cultivate Resistance*, 2007
linocut, 8" x 10"

Erok Boerer, *Clearchannel*, 2003
stencil, 12" x 19"

David Grant, *Kill 'em All*, 2005
linocut, 12" x 12"

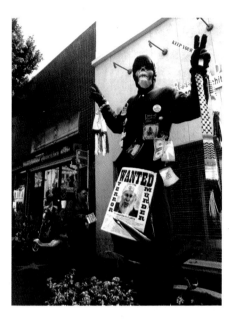

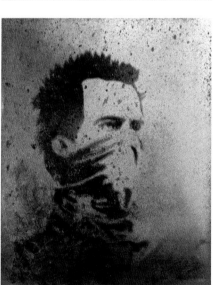

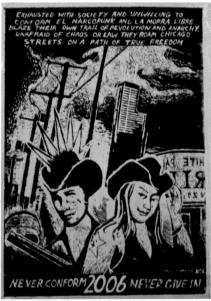

clockwise, from top left:
Sebastian Wagner, *Du bist kein Berliner*, 2003
screen print, 21.25" x 31"

Antonia Tricarico, *Wanted*, 2004
gelatin silver print, 11" x 14"

Juan Compean, *Untitled*, 2006
screen print, 13" x 17.5"

Sixten, *Riot*, 2003
stencil, 16" x 19.5"

next page, left:
ASARO, *Emiliano Zapata*, 2006
woodcut, 26" x 37.5"

next page, right:
Sanya Hyland, *Comandante Ramona*, 2006
screen print, 22.25" x 30"

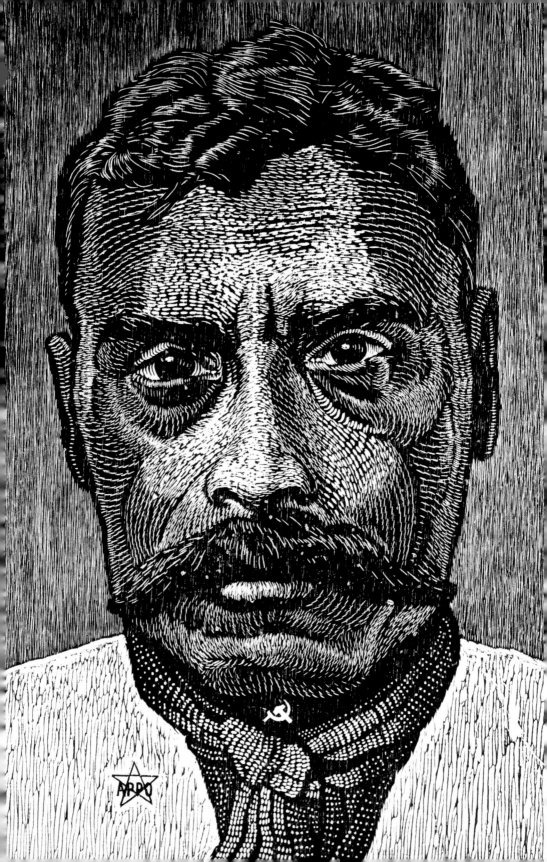

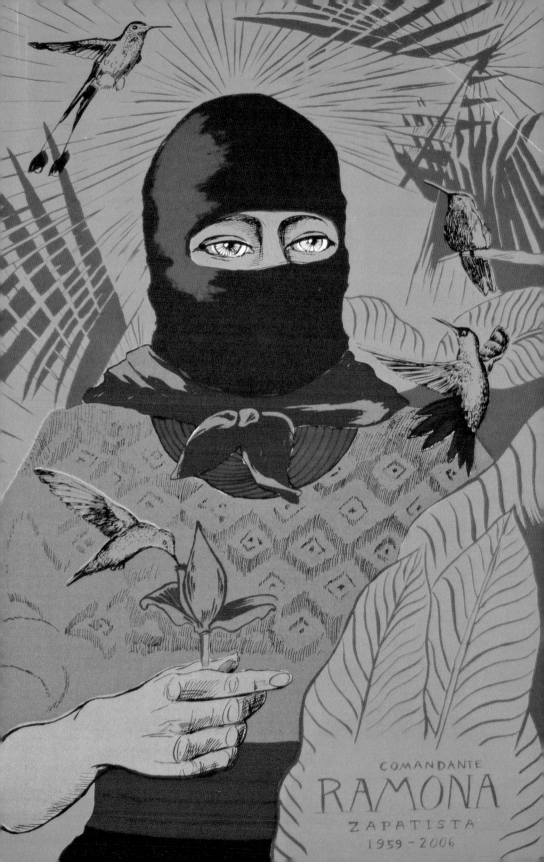

COMANDANTE
RAMONA
ZAPATISTA
1959 - 2006

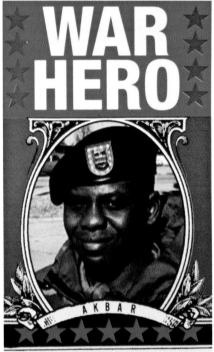

WAR HERO

SERGEANT ASAN AKBAR
326th Engineer Battalion

An American Muslim soldier charged with killing two officers and injuring fourteen fellow soldiers during an attack at a base in Kuwait days before they were scheduled to invade Iraq. He is accused of rolling grenades into command center tents of the 101st Airborne and then shooting soldiers as they exited.

SUPPORT DISSENTING TROOPS

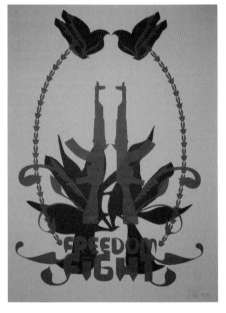

clockwise, from top:
Marc Lepson, *One Way*, 2003
screen print, 36" x 12"

BORF, *Untitled*, 2006
screen print, 19.5" x 19"

Geraldine Lozano, *Freedom Fighter*, 2007
screen print, 13.75" x 19.75"

Chris Cardinal/Closed Circuit, *War Hero*, 2005
screen print, 12.75" x 24"

WAR

3/8 EL BORFÉ -200666

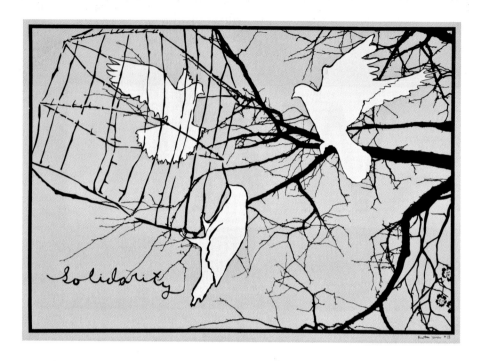

Kristine Virsis, *Solidarity*, 2005
screen print, 22" x 15"

Molly J. Fair, *Direct Action*, 2009
screen print, 14.5" x 11"

next page:
Lindsay Ballant & Brian Lightbody, *Peace Poster*, 2006
screen print, 22.25" x 28"

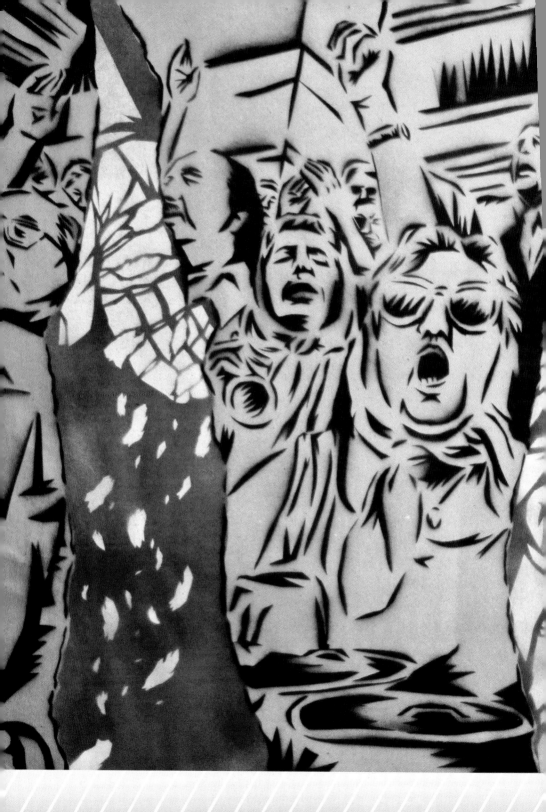

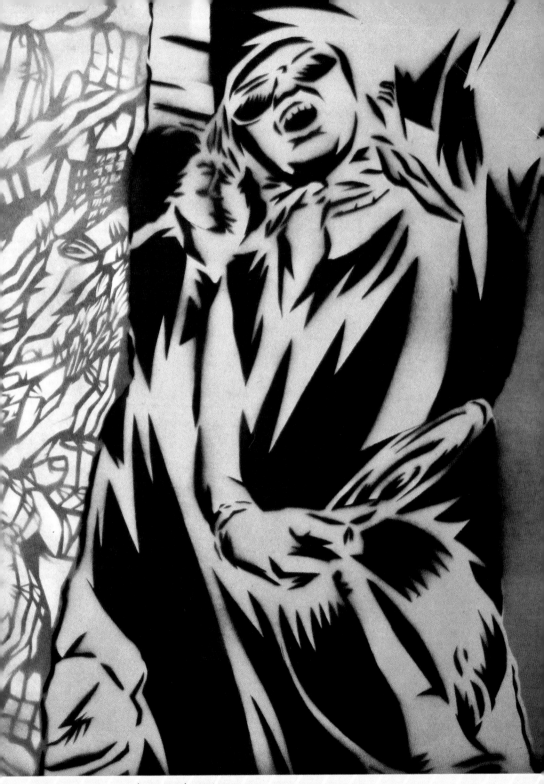

Erik Ruin, *Torn Surface (Argentina)*, 2006
stencil, 33.5" x 22.5"

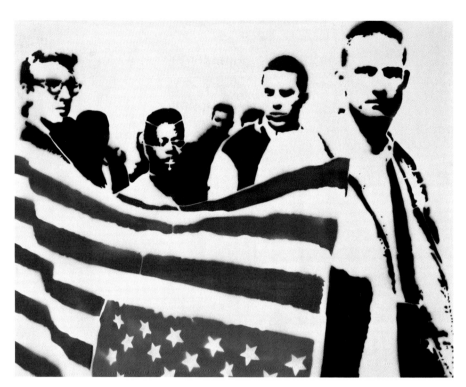

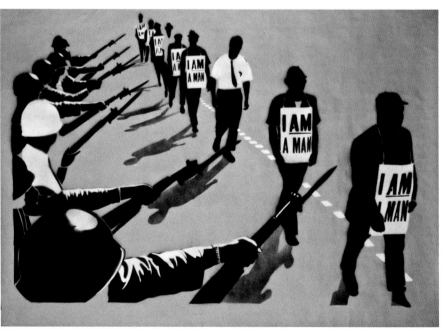

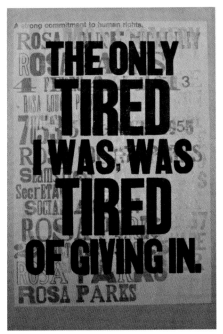
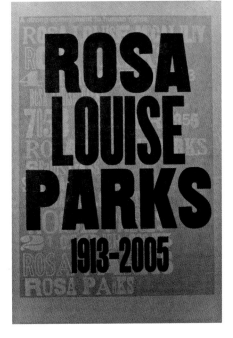

previous page:
Run Don't Walk, *Untitled*, 2006
stencil, 29" x 24"

Ryan Nuckel, *I Am a Man*, 2005
stencil, 34" x 25"

this page:
Amos Paul Kennedy, Jr., *Rosa Parks*, 2005
letterpress, nine 12.5" x 19" prints

"...and eve...if you win – yo...do know, don't yo...that you're going to inher...piles of ruins?"

"...we have always lived...in misery...for some time ye...and we will accommodate ourselves to it...don't forget, though, that the workers are the on...producers of wealth – we – the workers – run the machine...in the factories...we extract coal and minerals from the...mines, we built the cities...why shouldn't we rebuild them...new and better...to replace that which is destroyed?...ruins...do not scare us...we know that we...will inherit nothing more than ruins, because...the world in the last phase of their...history...the bourgeoisie will try to destroy...but, I repeat, we are...not frightened by ruins...because we carry...a new world in our...hearts, murmuring...efully – a world...which is growing...this very...instant..."

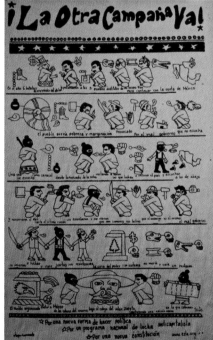

this page, clockwise:
Jen Smith, *Untitled*, 2005
carbon transfer, 3.75" x 8.5"

Refugio Solis, *La Otra Campaña*, 2005
screen print, 18" x 27.5"

Utopio-Luminarte, *¡La Otra Campaña Va!*, 2005
screen print, 18" x 27.5"

previous page:
Jean Cozzens, *Durruti*, 2007
screen print, 18.5" x 27.5"

Sarah Nicole Phillips, *Untitled (Wind Turbines)*, 2005
intaglio, monoprint & stencil, 15″ x 22″

Stephen Goddard, *The End of Automobiles*, 2004
linocut, 16″ x 14.5″

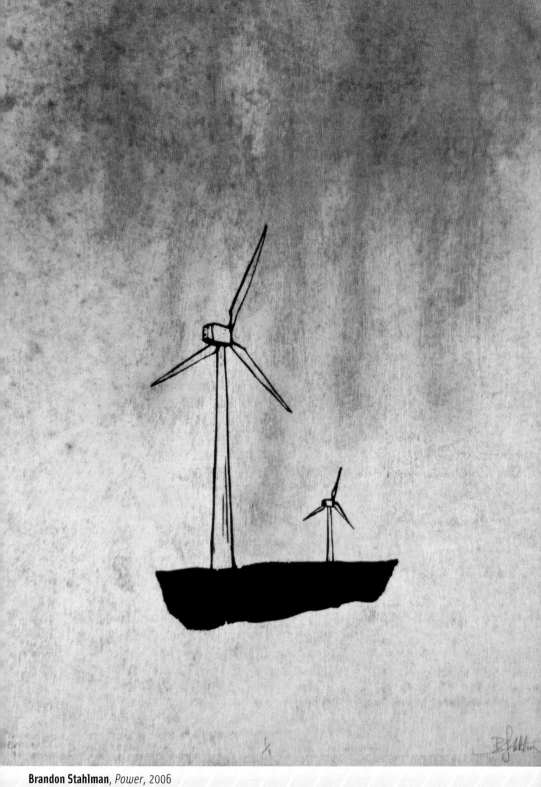

Brandon Stahlman, *Power*, 2006
monoprint, 17" x 20.5"

THE BEST PART ABOUT PRINTMAKING is the making, the crafting of things at a human scale. We live in a culture that privileges the *one* and the *many*. The one usually takes the form of a unique individual. In the case of the art world this means a singular artist-genius and "his" piece of art. The many takes the form of any number of universals, whether humanity, or just as often, the vague sea of consumers that constitutes "the market." The many is the endlessly reproducible commodity, with its allure of maximum production, maximum output and, of course, maximum exposure. Exposure is the common non-payment offered to reduce labor costs by convincing artists to give away their work for free: "I can't pay you much, but if you give me your art, tons of people will see it and isn't that why you make art? So everyone can see it?"

Something happens to art when it is mass produced, when it enters the cultural realm of the many. It changes, not because it all of a sudden looks different in an objective sense, but because people look at it differently. So it looks different in a subjective sense. And all looking is subjective. Maybe this has to do with intent. The logic of the commodity is oriented toward maximization: maximum exposure, maximum coverage, maximum output—to be consumed by every possible consumer.

What gets lost between these two poles—the one and the many—is the *few*. And that's why I like printmaking. It's the art form best suited to the few. This is the level of community—the network of people who you know and who know you, their friends, maybe even friends of friends, people you share some parts of your real life with. Not an abstract *whole*, but a more modest *some*. And making art for this some is really fun. Making thirty or forty or even a hundred prints for an event is a nice way of being part of a shared space. This is production at a human scale.

When you operate at the human scale, other non-commodity logics become possible, fueled by a desire to speak to, or communicate with, people that you share a lived-world with—people who are in the same town, who like the same stuff, who are committed to the same political projects, that sort of thing. So instead of speaking to the market, you might choose to speak with/in a community.

The strong connection I see between community and printmaking may have to do with where I learned how to print. I spent a number of years in Philadelphia as a member of a collective studio called Space 1026. Printmaking plays a central role at the Space, but tons of other stuff also happens there, not only other types of art making, but also monthly art openings, film screenings, music shows, and a lot of hanging out. Making prints at the Space was often a very social process—people would always be around while you were printing—not only other members of the Space but often friends, interns, and visitors as well. This meant that making prints was not separate from the community that the prints were being made for.

If only all work was like this, and the divisions between production spaces and consumptions spaces could be broken down, so we lived while working and worked while living. If only we could take back control from the market, control over the ways we creatively produce in this world. If only we could make art for and with each other and not for and with money....

What a better world it would be. It's with my eye on this better world that I continue to make prints with my friends.

-Jesse Goldstein

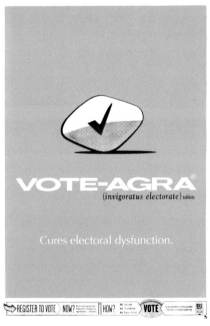

clockwise, from top left:

Jesse Goldstein, *Untitled*, 2008
screen print, 15" x 19.75"

Courtney Dailey, *every body moves against control*, 2005
screen print, 14" x 17.5"

Four Fingers & a Thumb, *Vote-agra*, 2004
screen print, 24" x 36"

Laurie D. Brown, *The Black Vote in Ohio, 2004?*, 2005
solar plate intaglio, 15" x 20"

Solidarity with the Palestinian People

تضامنا مع الشعب الفلسطيني

Solidaridad con el Pueblo Palestino

Melanie Cervantes, *La Resistencia*, 2008
screen print, 19.5" x 25.5"

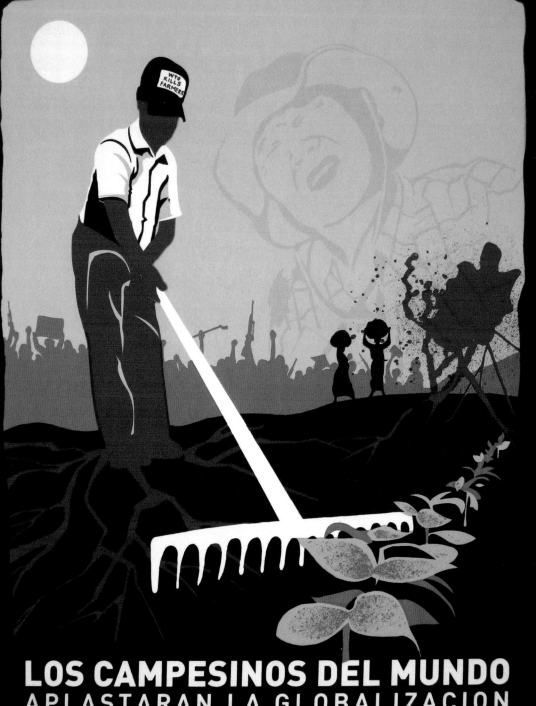

LOS CAMPESINOS DEL MUNDO
APLASTARAN LA GLOBALIZACION

FARM WORKERS OF THE WORLD, UNITE! SMASH THE WTO! 세계의 노동자는 WTO를 탄압한다

Favianna Rodriguez, *Los Campesinos del Mundo*, 2003
screen print, 19" x 24.75"

¡MAYO, EL DIA DEL TRABAJO

RICARDO FLORES-MAGÓN

Regeneración
¡TIERRA Y LIBERTAD!

1995

LUCIA GONZALEZ de PARSONS

CESAR CHAVEZ

EL MALCRIADO
VIVA LA HUELGA

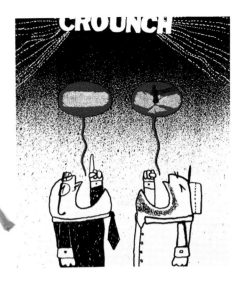

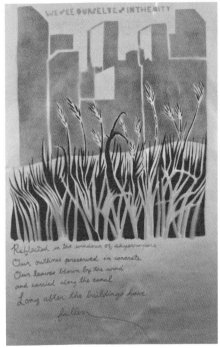

clockwise, from top left:
Seripop, *Crounch*, 2003
screen print, 18" x 20"

Setu Legi/Taring Padi, *Bangan Kesetaraan*, 2005
woodcut, 23" x 34.5"

Rocky Tobey, *Risk Everything*, 2005
screen print, 21" x 35"

Mackenzie Ogilvie, *We See Ourselves in the City*, 2006
stencil, 26" x 33.25"

previous page:
Carlos Cortéz, *May Day*, 1997
woodcut, 12.5" x 19"

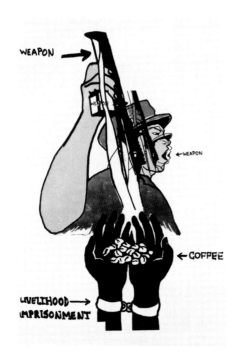

WEAPON

←WEAPON

←COFFEE

LIVELIHOOD→
IMPRISONMENT

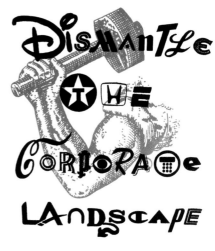

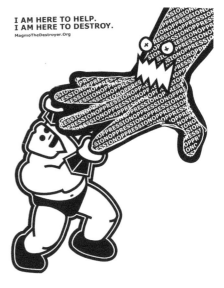

I AM HERE TO HELP.
I AM HERE TO DESTROY.
MagmoTheDestroyer.Org

KEEP YOUR COINS,
I WANT CHANGE

this page, clockwise from top left:
Alixa Garcia, *COLOMBIA*, 2006
screen print, 14.75" x 22.5"

Nicolas Lampert, *Dismantle the Corporate Landscape*, 2007
screen print, 19" x 25"

MAGMO the Destroyer, *MAGMO FIGHT: Oppression*, 2004
screen print, 18" x 24"

Meek, *Begging for Change*, 2004
stencil, 30" x 32"

next page:
Dan S. Wang, *Notice of Hearing*, 2004
letterpress, 12x17.25

When it comes to media and art making my life is divided in two. On one side there is the digital life. I leave trails through cyberspace; I laugh over email and through social networking sites. I blog and upload videos. I capture images, modify them, and post them. I consume entertainments, conduct research, check the weather, buy stuff, and stay in contact with people, all online. The other side is my analog life. I print using a Vandercook press, instruct students in black and white woodcut, and use an X-Acto way more often than I use Photoshop. I cut and paste paper, draw with pens and pencils, and set metal type.

Printing off wood and metal type represents a body of trade knowledge well on its way toward extinction. It is a one-way street. When the last of the metal typecasters pass (both human and machine), humanity may very well have to reinvent the wheel if there is ever a need to cast metal type again. But that is just the most obvious endangered element. Ask any letterpress typographer; the printing is the easy part. The hard part is the setting of the type, that is, the composition. Especially for anything artistic. I can fuss over it forever, tinkering with the endless puzzle we letterpress printers call the form. By contrast, the printing part is very fast and usually quite monotonous.

Hand composition is what is dying, not the printing. The letterpress revival has kept the printing alive, but the type is no longer being manufactured. What type there is, if it is being used at all, is wearing out. Younger letterpressers are mostly going towards photopolymer plates, on the one hand, and manually carved blocks, on the other. That perfect balance between human and machine struck by hand composition is becoming a relic of history, and, in practice, a void.

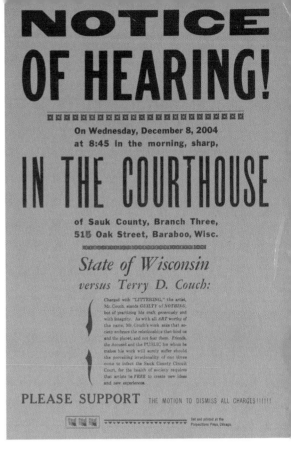

NOTICE OF HEARING!

On Wednesday, December 8, 2004 at 8:45 in the morning, sharp,

IN THE COURTHOUSE

of Sauk County, Branch Three, 515 Oak Street, Baraboo, Wisc.

State of Wisconsin
versus Terry D. Couch:

Charged with "LITTERING," the artist, Mr. Couch, stands GUILTY of NOTHING, but of practicing his craft generously and with integrity. As with all ART worthy of the name, Mr. Couch's work asks that society embrace the relationships that bind us and the planet, and not fear them. Friends, the Accused and the PUBLIC for whom he makes his work will surely suffer should the prevailing irrationality of our times come to infect the Sauk County Circuit Court, for the health of society requires that artists be FREE to create new ideas and new experiences.

PLEASE SUPPORT THE MOTION TO DISMISS ALL CHARGES!!!!!!

Set and printed at the Prepositions Press, Chicago.

Though I do believe that there is one, I keep doing it not for any particular handcrafted look, but for the simple reason of exercising a rare privilege. I get to live in the twenty-first century but practice a skill leftover from the nineteenth and early twentieth centuries, itself directly derived from the earliest forms of print communication. With some luck and effort maybe I can find younger somebodies willing and able to receive my knowledge, and keep the skill alive for a little longer. In a world in which capital dictates obsolescence, any practical grasp of that which has been shed by the industry of mass communication seems at least contrarian. And, depending on what one prints, of course, contrarianism can very quickly become resistance.

–Dan S. Wang

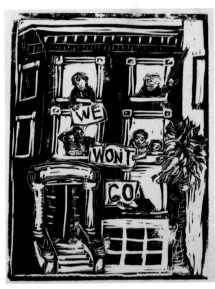

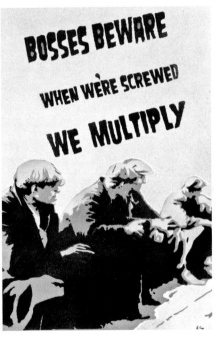

clockwise, from top:
Nicole Schulman, *Against the Wall*, 2005
linocut, 36" x 17.25"

Larry Cyr, *Untitled*, 2008
stencil, 14" x 22"

Melissa Klein, *We Won't Go*, 2005
linocut, 10" x 13"

previous page:
Seth Tobocman, *House Fist*, 2009
stencil, 12" x 17"

next page spread:
Fernando Martí, *La Resistencia Viene en Muchas Forms/Resistance Comes in Many Forms*, 2004
etching, 15" x 11"

I GOT INTO STENCILING A few months after I got back from Iraq in 2006. Prior to joining the military, I was a photojournalism major in college. The idea of documenting peoples lives and visually telling their stories is what attracted me to photography. For me stenciling is an extension of photography. It's a way for me to combine graphic arts and photography. I am a veteran of the Iraq War and come from a working class background. My experience with stenciling has given me a positive outlet to express my feelings about war and human struggle. *-Larry Cyr*

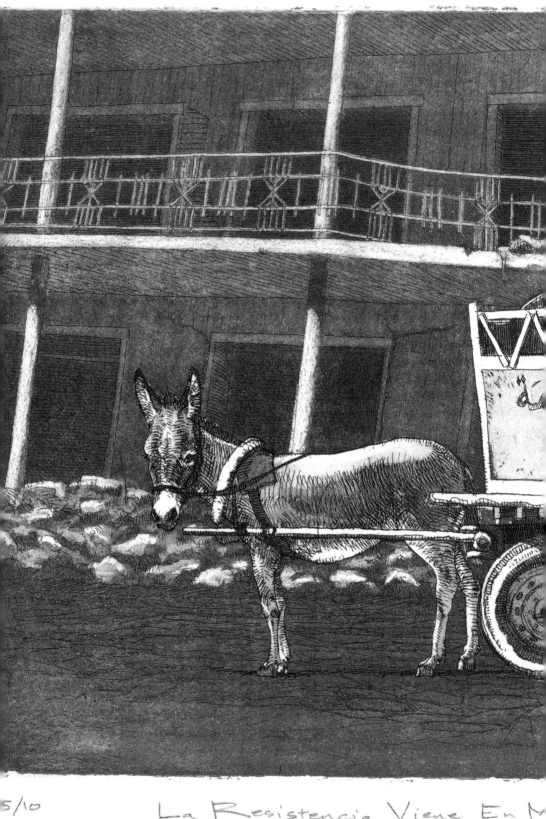

5/10 La Resistencia Viene En M

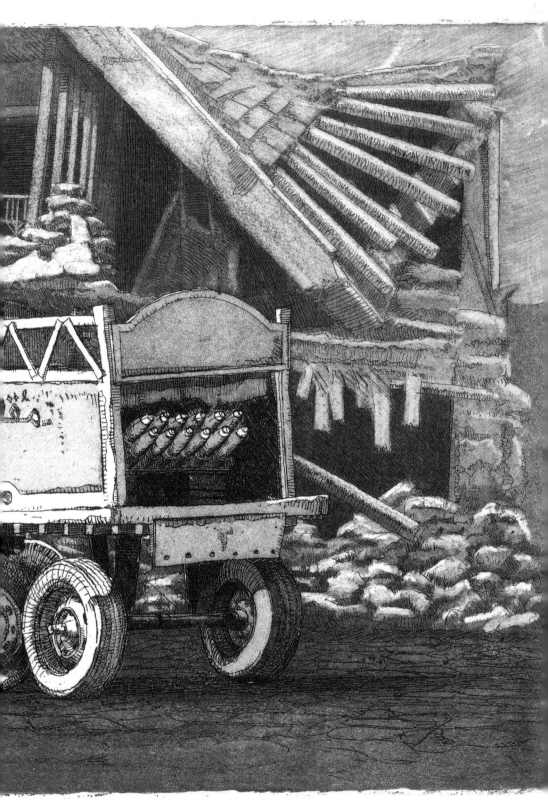

chas Formas Fernando Marti ___ 2005

exist

identity
awareness
movement
communication
creation
transportation
perseverance
joy

ence

mutual aid.
self-determination.
autonomy.

an army of lovers
shall not fail

LOVE
WHO
YOU
WILL

Anti-Capitalist Ass Pirates, *An Army of Lovers*,
2005
screen print, 16" x 11"

Shannon Muegge, *Untitled*, 2005
screen print, 29" x 21.5"

opposing page:
Ariana Jacobs, *I am an Idea, you are a receiver*,
2006
screen print, 12.5" x 19.25"

clockwise, from top:
Janet Attard, *Nine Bicycles*, 2006
stencil, 27" x 40"

Onyx Dixon, *make ready your dreams*, 2006
linocut, 11" x 15"

Freya Powell, *Untitled*, 2004
screen print, 10.75" x 10.5"

Daniel P. LoBue, *By Hand*, 2002
dry-point etching, 15" x 20"

Katherine Dessert, *Child*, 2005
stencil, 7" x 13"

Hervé Constant, *From the same wilderness...*,
1992
screen print, 27" x 39"

Ally Reeves, *Grow Despite*, 2005
stencil, 12" x 18"

Watie White, *Hotspot: Morse Ave Westbound*, 2005
linocut, 35" x 22.5"

Aileen Bassis, *Immigrant Crossing #1*, 2003
monoprint & thread, 22" x 15"

Leigh Klonsky, *Dispatch from April 10th*, 2005
monoprint & paper lithograph, 15" x 11.25"

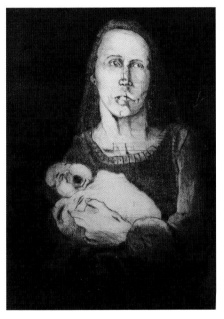

clockwise, from top left:
Michael Dal Cerro, *PEACE*, 2004
woodcut, 6" x 8"

Maril Hazlett, *Because We All Have T(w)o*, 2005
linocut, 15" x 19"

Katie Truskoski, *Meena*, 2004
linocut, 16" x 24"

Rebecca Wayt, *Modern Motherhood*, 2005
engraving & mezzotint, 15" x 19.75"

clockwise, from top left:
Mark Thomann, *Bauer*, 2004
screen print, 19.5" x 23.5"

elin o'Hara slavick, *Proud Red Banners, Torn*, 1998
screen print, 35" x 35"

Ellen Schillace, *It Takes A Village*, 1995
screen print, 22" x 30"

Ryan O'Malley, *Watch Yer Mouth*, 2005
lithograph & screen print, 16" x 20"

next page:
Dionne Haroutunian, *Self Portrait in the Times of War II*, 2005
monotype, 20" x 36"

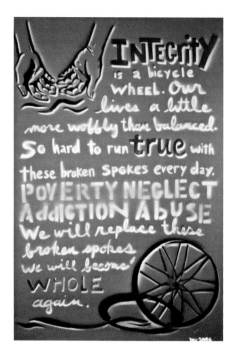

clockwise, from top left:
Bec Young, *Untitled*, 2005
stencil, 23" x 35"

Pete Yahnke, *Red*, 2005
screen print (from original linocut), 22" x 18"

Joan Stuart Ross, *Stop the Dead V*, 2005
encaustic, digital & relief print, 5.5" x 8.5"

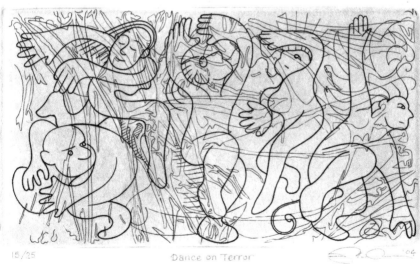

You Are Beautiful, *You Are Beautiful*, 2005
paper cut, 26.5" x 21.5"

Jared Wickware, *Dance on Terror*, 2004
engraving, 12" x 9"

children

be gay.

clockwise, from top:
Aaron Krach, *Pioneer 10 Vanity Mirror*, 2002
screen print, 8" x 10"

Daryl Vocat, *Children be Gay*, 2002
screen print, 11" x 17"

Mary Tremonte, *Roy and Silo: Powerful*, 2008
screen print, 13.25" x 14.75"

previous page:
Sara Thustra, *Respect Your Spirit*, 2006
screen print, 21.5" x 28"

"With all our boasted reforms, our great social changes, and our far-reaching discoveries, human beings continue to be sent to the worst of hells, wherein they are outraged, degraded, and tortured, that society may be "protected" from the phantoms of its own making."

Prison, a social protection? What monstrous mind ever conceived such an idea? Just as well say that health can be promoted by a widespread contagion."

Emma Goldman

1869–1940

"HAVE NOT PRISONS — WHICH KILL ALL WILL AND FORCE OF CHARACTER IN A MAN, WHICH ENCLOSE WITHIN THEIR WALLS MORE VICES THAN ARE MET WITH ON ANY OTHER SPOT OF THE GLOBE — ALWAYS BEEN UNIVERSITIES OF CRIME?"

PETER KROPOTKIN

1842 – 1921

teach compassion

top:
Elizabeth Robertson, *Emma Goldman/Peter Kropotkin*, 2006
screen print (diptych), 11" x 17"

bottom:
Amy Rice & Jennifer Davis, *Untitled*, 2006
stencil, 25" x 20"

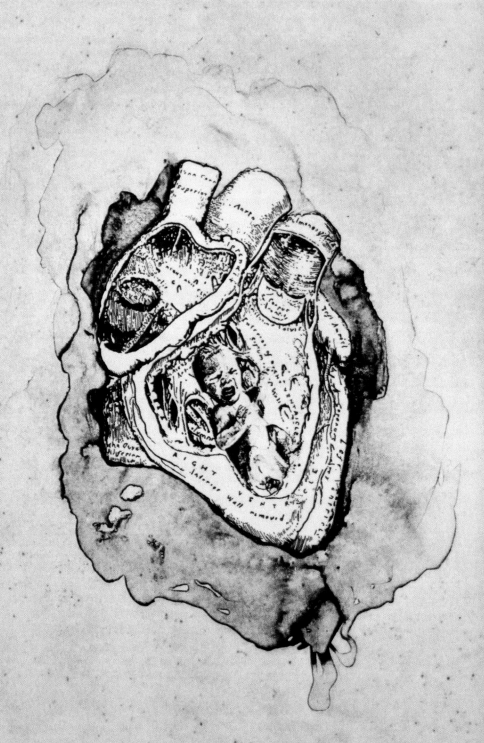

Diana Jacobs, *Baby in the Heart*, 1997
etching, 14" x 20"

PRINTMAKING HAS BECOME AN ART of resistance. In many ways, it comes as no surprise that in an age of advancing "technological reproducibility," as Walter Benjamin so powerfully wrote in 1939, many contemporary artist-activists have intentionally decided to reconfigure the print within their working practices. Unlike the "aura-less" reproductions that Benjamin described in his essay "The Work of Art in the Age of its Technological Reproducibility," I turn to the hand-printed image to confront an ever-increasing digitized visual environment. We commonly walk around with self-mediated devices, such as iPhones and Blackberries, in our hands, while corporate-controlled visual messages attack us on the aural and visual fronts. Through the creation of the artisanal craft of the relief print, I begin to escape this colonizing space via an act of emancipation.

Just as printmaking is a mode of (creative) production capable of evading the predicament of mass manufacturing, the popular print tradition attempts to operate outside the domain of the contemporary art market. Although the print has the potential to be either a reified fine art object or a mass-produced commodity, my own work is printed in small (often unnumbered) runs, creating a body of accessible, yet non-elitist images. The tactility and expediency of the print is paramount to its capacity to circulate within wide audiences, without being contained by capitalist social relations.

In the world of late-capitalist consumption, where mass-produced commodities and highly designed products are naturalized, the creation of hand-made objects becomes an overt act of resistance. By using the language of anti-capitalist activism and Indigenous visual cultures, I have decided to produce intentionally "crude" objects that, if nothing else, challenge the ambiguity of the contemporary artworld by operating within a tradition of political didacticism. Through the production of relief prints, I attempt to give narrative to a particular anti-colonial and anti-capitalist desire, one shared by many of the artists in *Paper Politics*. In turn, as a printmaker I become a uniquely visual storyteller.

Commonly printing onto found materials, such as re-used grocery sacks—a material that is becoming increasingly rare with the abundant utilization of plastic bags—I see my art making practice as the embodiment of my politics. The printed image and the materials I work with remain an expression of my day-to-day realities. In a consumer-based society, the print becomes a small (productive) expression against the alienation I feel. My objects mark my existence and declare that I am alive. Just like the cave paintings and petroglyphs created by societies the world over, these little acts of printmaking make their mark on the world.

Through the printed form, I engage with the history of art from an anti-colonial and anti-capitalist position. This hemispheric print tradition is strong: from the Taller de Gráfica Popular in Mexico to the wonderful array of Cuban serigraphs, to the work of Emory Douglas and Malaquías Montoya, two recent U.S. examples. Alongside the other artists involved in *Paper Politics*, I refuse to acquiesce to the dominant modes of contemporary art. Printmaking commonly exists outside the purview of the art establishment. In fact, the marginalization of the printed object sparks my desire to continue working with this media.

In the end, the print serves as an alternative to the mechanization of contemporary life by offering a specter of humanity in an alienated existence. Through its heterodox visual language, new and generative human relations can be produced.

—Dylan Miner

clockwise, from top:
Dylan Miner, *Anarco-Syndicalismo Americano: Ricardo Flores-Magon y Joe Hill*, 2006
linocut, 14″ x 12.5″

Jesus Barraza, *Edward Said*, 2004
screen print, 19″ x 25″

Raoul Deal, *Portrait of Larry Adams*, 2009
woodcut, 19″ x 25″

next page spread:
Ginger Brooks Takahashi, *i no we can reign here*, 2005
screen print, 25″ x 9.5″

Miriam Klein Stahl, *Untitled*, 2005
linocut, 29″ x 10.5″

clockwise, from top:
Monkey/CBS, *Subterranean Internacional*, 2003
screen print, 24.75" x 9.25'"

Shaun Slifer, *Let Us Now Bring Back the Wolves*, 2009
letterpress & stencil, 8.25" x 12.5"

Meredith Stern, *Cleaning the Neighborhood*, 2004
linocut, 24" x 36"

next page:
Jan Danebod, *Reservat per a propaganda electopal II*, 2007
woodcut, 27.5" x 39.5"

acknowledgements

Paper Politics wouldn't have been possible without the help of many people along the way. The original exhibition would never have happened without Jessica, Aaron, and Tracy at *In These Times*; Edmar and everyone that organized Select Media Fest; all the artists that contributed work; and everyone that helped hang and document the show, as well as sell prints. I am deeply indebted to Joseph Pentheroudakis and all at Seattle Print Arts for turning *Paper Politics* into a premier collection of political printmaking. The printmaking community in Seattle really embraced me and what I was trying to do, and helped launch the start of five years worth of exhibitions, which have likely been seen by tens of thousands of people. A giant thanks to all the artists that have been involved in the project, and to Deborah Caplow and Eric Triantafillou for their essays. The book wouldn't have happened without the support and generosity of Ramsey, Craig, Andrea, and all at PM Press.

I would also like to thank Gabriel Cohen for being the best assistant ever; Kevin Caplicki for photographing much of the work; Dara Greenwald; my family; the entire Justseeds Artists' Cooperative; the Phinney Center Gallery in Seattle; Raphael Fodde and the 5+5 Gallery in Brooklyn; Pete Yahnke and the Food for Thought Gallery in Portland; Gary Tuma, Nicolas Lampert, and the Walker's Point Center for the Arts in Milwaukee; Michael Flanagan and the Crossman Gallery in Whitewater, Wisconsin; Norman Nawrocki, Jesse Purcell, and everyone in Montreal that worked on L' Art & Anarchie Salon 2007; Michelle Smythe, Mike Stephens, and the K Space Contemporary in Corpus Christi, Texas; Andrew Mount and the Dowd Gallery in Cortland, New York; Natalia Mount and the Red House Gallery in Syracuse, New York; Thea Duskin and the Ghostprint Gallery in Richmond, VA; Carol Wells and all at the Center for the Study of Political Graphics; and the hundreds of people who have helped to find venues and to hang, promote, pack, and transport the *Paper Politics* exhibition for the past five years.

artists

Melba Abela (San Francisco, CA USA) ⋆ p49
Melba Abela was born in the Philippines and earned degrees in Fine Arts and Education at the San Francisco Art Institute and the University of the Philippines. Her work has been exhibited in various US cities and in the Philippines. Her writings as well as art have appeared in Trepan (CalArts), *Santa Clara Review*, and in art books and poetry anthologies.

Irene Abraham (San Diego, CA USA) ⋆ p54
IreneAbraham.com

Morgan F.P. Andrews (Philadelphia, PA USA) ⋆ p84
Morgan F.P. Andrews makes prints and puppet shows, teaches yoga and Theater of the Oppressed workshops, and runs a vegan luncheonette when he feels like it. He's contributed writings and art to *Puppetry International*, *Globalize Liberation*, *Reproduce & Revolt*, and *Realizing the Impossible*. Morgan is interested in hearing from other artists whose work is shaped by eye diseases and visual impediments.
PuppetUprising.org

Anti-Capitalist Ass Pirates (Montreal, Canada) ⋆ p114
Lespantheresroses.org/asspirates.htm

ASARO/Oaxacan Assembly of Revolutionary Artists (Oaxaca, Mexico) ⋆ p86
ASARO was born in 2006 out of the teachers' strike and widespread social movements in Oaxaca. They have dedicated themselves to making accessible, popular art and plastering the walls of Oaxaca City with prints, posters, graffiti and stencils that reflect the demands and vision of the popular movement.
Web.mac.com/dfteitel/iWeb/ASAR-O/Home.html

Janet Attard (Toronto, Canada) ⋆ p116
Janet Attard is a bicycle stencil artist. She has been making bicycle stencils since 1995. People call her Janet Bike Girl.
Flickr.com/photos/janetbikegirl

Jon Paul Bail (Alameda, CA USA) ⋆ p42
Jon Paul Bail is currently printing at Political Gridlock in Alameda as well as in Oakland at the Firehouse Rockposter Co.
Gridlock.com

Lindsay Ballant & Brian Lightbody (Brooklyn, NY USA) ⋆ p91
LindsayBallant.com

Paul Barron (Oakland, CA USA) ⋆ p84
Paul Barron is currently traveling with the *Art vs Cops* collection of anti-police brutality artwork. He's also featured in the *Yo! What Happened to Peace?* exhibition.
PaulBarron.org

Jesus Barraza (San Leandro, CA USA) ⋆ p131
DignidadRebelde.com

Aileen Bassis (Jersey City, NJ USA) ⋆ p120
Aileen Bassis is an artist making work about social and political issues in photography, printmaking, book arts and installation. She's exhibited her work extensively, including at the University of Pennsylvania, Jersey City Museum, Queens Museum, and Ohio University. She also has work in the collection of Wellesley College and the Royal Museum of Fine Arts in Antwerp.
AileenBassis.com

Brandon Bauer (Fond du Lac, WI USA) ⋆ p60
Brandon Bauer is a multi-disciplinary artist living and working in Wisconsin. Brandon's work has been exhibited and screened nationally and internationally in a variety of venues, festivals, and institutions. His work has been produced in DVD editions, used as illustrations for various editorial publications and books, and published in poster editions.
Randomculture.wordpress.com

Erok Boerer (Pittsburgh, PA USA) ⋆ p84
Erok Boerer spends most of his time and energy fighting car culture in his adopted hometown of Pittsburgh. Other times he likes to go far, far away, often on his bicycle.

BORF (Washington, DC USA) ⋆ p89
Borfyou.com

Josh Kramb, *Built for Comfort*, 2008
woodcut, 26.5" x 20"

Laurie D. Brown (Seattle, WA USA) ★ p101
Born in New York, Laurie Brown received her BFA
in printmaking from the University of Oregon.
Laurie co-founded Pressworks Printmaking Co-
operative. Her award-winning prints have been
included in many shows, regionally, nationally,
internationally, and in private collections.
LaurieDBrown.com

BSAS Stencil (Buenos Aires, Argentina) ★ p38
BSASstencil.com.ar

Katie Burkart (Portland, OR USA) ★ p48
katieburkart@hotmail.com

Kevin Caplicki (Brooklyn, NY USA) ★ p59
Kevin Caplicki is a New York-based artist who
uses print making and three-dimensional
installations to convey anarchist critiques
of the world.
Justseeds.org

Christopher Cardinale (Brooklyn, NY USA) ★
p34-35
Christophercardinale.com

Chris Cardinal/Closed Circuit (Portland, OR USA)
★ p88
Chris thankfully makes a living screen printing
for Printed Matter Screen Printing. When not
working he is either skating, at a punk show, or
wishing he had a couple days to just sleep in.
PrintedMatter.info

John Carr (Los Angeles, CA USA) ★ p79
YoPeace.org

Daniel Cautrell (Duvall, WA USA) ★ p67
Dancautrell.com

Melanie Cervantes (San Leandro, CA USA) ★ p102
Melanie Cervantes creates a powerful visual
language to declare that a peaceful, sustain-
able, and just world is possible. Her art moves
those viewed as marginal to the center and
features empowered youth, elders, women,
queers, indigenous peoples, and communi-
ties of color. Melanie views her art practice as
an important component of a growing social
movement for global social justice.
DignidadRebelde.com

etta cetera (Pittsburgh, PA USA) ⋆ p55
etta cetera is currently focused on the struggle to abolish white supremacy and the prison industrial complex. etta strives to engage in healthy relationships and to relentlessly practice self love. etta has been mailing political art to the White House since 2004, starting with the print in *Paper Politics*.
Thomasmertoncenter.org/fedup

Tom Civil (Melbourne, Australia) ⋆ p36
Tom Civil (AKA Civilian) is a D.I.Y. artist and activist graphic designer who has self published posters, zines, stickers and newspapers. His stencil work has been featured in the publication *Melbourne Stencil Art Capital* and in the film *Rash*. He was a featured artist in the Melbourne Stencil Festival 2004/05 and in 2008 as part of the London Cans Festival. Tom is also co-founder of the radical publisher Breakdown Press.
Flickr.com/photos/tomcivil

Juan Compean (Chicago, IL USA) ⋆ p85
Juan Compean is a visual artist currently working in Chicago.
13por13.com

Sue Coe (Deposit, NY USA) ⋆ p40
Graphicwitness.org/coe/enter.htm

Gabriel Cohen (Brooklyn, NY USA) ⋆ p44
Gabriel Cohen is a printmaker and activist living and working in Brooklyn, NY. With a big soft spot for collaboration, his work often revolves around themes of libertie, egalitie, and catastrophe.
PangaeaCorps.com

Hervé Constant (London, England) ⋆ p117
Hervé Constant is a London-based French artist. He was born in Casablanca, Morocco and was brought up for over ten years in an orphanage in Hyeres in the south of France. Hervé's work is a mixture of different interests and social and cultural influences.
HerveConstant.co.uk

Melissa Cooke (Oconomowoc, WI USA) ⋆ p71
MelissaCookeArt.com

Carlos Cortéz (Chicago, IL USA/1923-2005) ⋆ p104

Politicalgraphics.org/exhibitions/Carlos Cortez/ CarlosCortez.htm

Jean Cozzens (Providence, RI USA) ⋆ p96
SecretDoorProjects.org

Nelson Crespo (London, England) ⋆ p41
NelsonCrespo.blogspot.com

Lydia Crumbley (Portland, OR USA) ⋆ p63
Lydia Crumbley is a printmaker who lives and works in Portland.

Maureen Cummins (High Falls, NY USA) ⋆ p70
Maureen Cummins has been producing limited edition prints and artist books for the past fifteen years. Her work is represented in over one hundred permanent public collections, including the Brooklyn Museum, the Library of Congress, the National Gallery, and the Walker Art Center. She currently lives with her family in upstate New York but maintains close ties to Manhattan and Brooklyn.
MaureenCummins.com

Mathew Curran (Raleigh, NC USA) ⋆ p48
Mathew Curran is best known for his elaborate stencil work. His stencils use distorted figures and industrial objects to capture the virility and stamina of street life.
Mathewcurran.com

Larry Cyr (Seattle, WA USA) ⋆ p109
Larryccyr.blogspot.com

Patricia Dahlman (Lyndhurst, NJ USA) ⋆ p73
Patricia Dahlman is a sculptor who also makes prints. Due to the policies of the George W. Bush administration, Patricia organized the *War and Peace Print Project* to help bring about change. Prints were made for the project and sold as a benefit for MoveOn.org and a book of prints was made titled *We Live in a Divided Country, Try to Bridge That Gap*.
Afonline.artistsspace.org/view_artist.php? aid=609

Courtney Dailey (San Francisco, CA USA) ⋆ p101
Courtney Dailey is a maker of objects and projects and exhibitions, currently from her new home base of San Francisco.

Jeff Stark, *Untitled*, 2006
stencil, 11" x 17"

Michael Dal Cerro (Lyndhurst, NJ USA) ⋆ p121
Michael Dal Cerro is a painter/printmaker who has shown his work throughout the U.S., recently at the International Print Center in New York City, the Jersey City Museum and the Frans Masereel Centrum in Belgium. His work is included in many collections, including the Achenbach Foundation For Graphic Arts, the University of Washington-Seattle, the Microsoft Corporation, the University of Dallas, the University of Richmond Museums, and the New York Public Library.
Afonline.artistsspace.org/view_artist.php?aid=610

Jan Danebod (Copenhagen, Denmark) ⋆ p135
122x244@menneske.dk

Tom Davie (Cincinnati, OH USA) ⋆ p73
Tom is an Ohio native who has worked as an artist, graphic designer, and design educator. He is the founder of studiotwentysix2, which integrates painting, printmaking, and graphic design to offer an eclectic mix of client-based design, concept-driven paintings, and limited-edition prints.
Studiotwentysix2.com

Raoul Deal (Milwaukee, WI USA) ⋆ p131
Raoul Deal is an artist and educator who teaches in the Peck School of the Arts at the University of Wisconsin-Milwaukee, where he is the Cultures and Communities Program Artist-in-Residence.

Alejandra Delfin (Bronx, NY USA) ⋆ p69
Studio889.org

Arthur Desmarteaux (Montréal, Canada) ⋆ p51
Arthur Desmarteaux studied visual arts at the University of Québec in Montréal, graduating in 2003. He is currently an active member of Graff printing studios in Montréal. He has exhibited his works across Canada and abroad.
Arthuro.ca

Katherine Dessert (Lawrence, KS USA) ⋆ p117
katherinedessert@yahoo.com

James Dodd (Mile End, Australia) ⋆ p53
James Dodd has exhibited widely across Australia in artist-run, publicly funded, and commercial spaces. His work traverses the boundaries between visual street culture, alternative use of urban space, and existing gallery conventions.
James-Dodd.blogspot.com

Dragon Dance Theater (Worcester, VT USA) ⋆ p65
DragonDanceTheatre.com

Alec Icky Dunn (Portland, OR USA) ⋆ p19
Blackoutprint.com

Emek (Portland, OR USA) ⋆ p42
Emek.net

Molly J. Fair (Brooklyn, NY USA) ⋆ p90
Molly Fair is a New York-based artist and a member of Justseeds Artists' Cooperative.
Justseeds.org

John Fekner & Don Leicht (Bayside, NY USA) ⋆ p55
Throughout their careers, working together or independently, John Fekner and Don Leicht

have explored a wide range of media including handwritten poems, spray-painted messages, steel and aluminum work, and sculptural soundscapes. Since the 1970s their work and installations addressing social issues have been seen in the streets, alternative spaces, galleries and museums worldwide.
Streetartmuseum.com/collaboration/

Karen Fiorito (Los Angeles, CA USA) ⋆ p81
Karen Fiorito is originally from Philadelphia, and currently resides in Los Angeles. She has exhibited her art nationally and internationally, and her work has appeared in such publications as Art in America, The Philadelphia Inquirer, Hustler, LA Weekly, and URB Magazine. She currently owns and operates Buddha Cat Press, her own fine art printmaking studio and publishing company.
KarenFiorito.com

Four Fingers & a Thumb (Portland, OR USA) ⋆ p101
Citizengraphics.com

Nicholas Ganz/Keinom (Essen, Germany) ⋆ p33
Nicholas Ganz is a freelance artist, photographer and author. He has been painting in the streets since the mid-1990s and published Graffiti World in 2004 and Graffiti Woman in 2006. For the last couple years he has been focusing on his photographic expression and documents social environments, movement struggles and humanitarian themes. In 2009 his book Burma: The Alternative Guide was published.
Keinom.com

Garage Collective (Christchurch, New Zealand) ⋆ p33
GarageCollective.blogspot.com

Alixa Garcia (Brooklyn, NY USA) ⋆ p106
Alixa Garcia is a print maker, painter, performance artist, and poet who uses her art at the service of her vision for collective transformation and self-determination.
ClimbingPoetree.com

Kathryn Glowen (Arlington, WA USA) ⋆ p81
Lorindaknight.com/artists/119

Goatskull (Portland, OR USA) ⋆ p31
Radioactivefuture.com/perm-goat.php

Stephen Goddard (Lawrence, KS USA) ⋆ p98
Stephen Goddard studied printmaking at Pasadena City College, Grinnell College, Tthe Minneapolis College of Art and Design, and the University of Iowa.
People.ku.edu/~goddard/

Kyle Goen (Brooklyn, NY USA) ⋆ p61
When the theatre is on fire, we are obligated to scream.
Kylegoen.net

Jesse Goldstein (Brooklyn, NY USA) ⋆ p101
Jesse Goldstein teaches sociology at Baruch College, and is a Ph.D. student at the City University of New York. He learned how to screen print as a member of the Philadelphia arts collective Space 1026, with which he has participated in a number of art shows and installations.
Space1026.com

Peg Grady (Santa Margarita, CA USA) ⋆ p37
PegGradyArt.com

Jesse Graves (Cross Plains, WI USA) ⋆ p84
Jesse Graves is a jewelry metalsmith and street artist currently residing in Milwaukee.
Mudstencils.com

David Grant (Brooklyn, NY USA) ⋆ p84
David Grant is an artist and designer living in Brooklyn. He is fond of trade unions, pizza, and the Appalachians.

Dara Greenwald (Brooklyn, NY USA) ⋆ p37
Dara Greenwald is a media artist.
DaraGreenwald.com

Beth Gutelius (Chicago, IL USA) ⋆ p75
bgutelius@gmail.com

Dirk Hagner (San Juan Capistrano, CA USA) ⋆ p38
German-born Dirk Hagner has an MFA in printmaking and creates contemporary works on paper. European roots in his works combine with Asian, American, and Mexican traditions. The techniques he uses are relief, letterpress, and etching, with occasional stencil printing.
DirkHagner.com

Erin Hall (Baltimore, MD USA) ⋆ p49
Erin Hall's work addresses the surface, structure, and content of daily newspapers in order to look more closely at the way we receive information and the way newspapers represent certain historical events.

Kari Hansen Couture (Milwaukee, WI USA) ⋆ p72
Greenpear.com

Dionne Haroutunian (Seattle, WA USA) ⋆ p123
Dionne Haroutunian is a Seattle-based printmaker who has shown her work regionally, as well as throughout the U. S., Europe, China, Mexico, and Africa. She is the founder of the Sev Shoon Arts Center, a printmaking studio that offers 24/7 access, classes and exhibition space. She is a co-founder of BallardWorks and a founding member of Seattle Print Arts.
Sevshoon.com/dionne.html

Deborah Harris (Berkeley, CA USA) ⋆ p78
Deborah Harris is a painter and printmaker working in the San Francisco Bay Area. In addition to her studio practice, she has taught widely for over thirty years, currently at Pixar Corporation and the Sawtooth School.
Deborah-harris.com

Carol Hayman (Austin, TX USA) ⋆ p42
Carol Hayman is a professor of anthropology at Austin Community College. Her award-winning prints and photographs have been exhibited and published locally, nationally, and internationally.
Womenprintmakers.com/members.asp?v=portfolio&memberID=23

Art Hazelwood (San Francisco, CA USA) ⋆ p59
Art Hazelwood has focused in recent years on organizing a nationwide coalition of political art shows called the *Art of Democracy*. He's also been working with homeless rights organizations creating artwork, organizing poster campaigns and curating a traveling exhibition called *Hobos to Street People: Artists' Responses to Homelessness From the New Deal to the Present*.
ArtHazelwood.com

Maril Hazlett (Northeastern KS USA) ⋆ p121
Maril Hazlett, Ph.D., is an independent scholar who lives and gardens in rural northeastern Kansas. She earned her undergraduate degree at Amherst College and her Ph.D. in environmental history from the University of Kansas.

Dusty Herbig (Syracuse, NY USA) ⋆ p68
DustyHerbig.com

John Hitchcock (Madison, WI USA) ⋆ p67
John Hitchcock's current artworks are based on childhood memories and stories of growing up in the Wichita Mountains of Oklahoma next to the U.S. field artillery military base Fort Sill. He explores notions of good, evil, death, and life cycles. His depictions of beasts, animals, and machines act as metaphors for human behavior and cycles of violence.
Hybridpress.net

Janette K. Hopper (Pembroke, NC USA) ⋆ p61
Janette Hopper's first series of linoleum prints were made in 1992 in Denmark when she was on a Fulbright Exchange; the prints are now in public and private collections. Strong graphic images give her a voice to speak about concerns she has about our culture. She received an MFA from the University of Oregon and is currently a professor in the art department at University of North Carolina at Pembroke.
Janettekhopper.com

Randal O. Hutchinson (Seattle, WA USA) ⋆ p80
Randalowen.blogspot.com

Sanya Hyland (Jamaica Plain, MA USA) ⋆ p85
Sanya Hyland was born in Petaluma, California. She lives and works in Boston as a letterpress printer and illustrator.
Sanyahyland.com

Ariana Jacobs (Portland, OR USA) ⋆ p115
Ariana Jacobs's work focuses on public culture and conversation.
Publicwondering.org

Diana Jacobs (Los Angeles, CA USA) ⋆ p129
Dianajacobsstudio.com

Alfonso Jaramillo (San Francisco, CA USA) ⋆ p63
Alfonsojaramillo.blogspot.com

Rebecca Johnson (Los Angeles, CA USA) ⋆ p55
Rebecca Johnson was born and raised in Los

Angeles, where she runs an art and design business, Bughouse, with her husband. Her medium is chosen according to what is most appropriate for the subject and mood, ranging from painting to mixed media to photography. Her illustrations have appeared in the publications *The Design of Dissent*, *Yo! What Happened to Peace?*, and *Reproduce & Revolt*, and in the permanent collection of the Center for the Study of Political Graphics. *Bughouse.com*

Elzbieta (Elka) Kazmierczak (Champaign, IL USA) ★ p66
Elzbieta Kazmierczak is a printmaker, book designer, and survivor of abuse who emigrated from Poland. She is the former head of the illustration program at the University at Buffalo. She uses creativity for the empowerment and healing of women who have experienced trauma and abuse.
Art4e.org

Amos Paul Kennedy, Jr. (Akron, AL USA) ★ p95
Kennedyandsonsfineprinters.com

Melissa Klein (Washington, DC USA) ★ p109
Melissa Klein originally made this print to accompany an article by Sara Shortt about housing rights in San Francisco. She currently lives in Washington, DC where she is a member of Puppet Underground, a social justice arts collective.

Layne Kleinart (Seattle, WA USA) ★ p65
Layne Kleinart holds fine art degrees in painting and printmaking from the University of Hawaii and the University of Washington. Her work was included in recent exhibits in China, in Mexico, and at the Seattle Art Museum Gallery. The subject of adolescence is an ongoing interest of Kleinart's, as she responds to that emotional juncture of innocence and discovery.
Laynekleinart.com

Tyler Kline (Philadelphia, PA USA) ★ p37
Southern Rebel Living in Yankee Town and Loving It.
Inliquid.com/artist/kline_tyler/kline.php

Klutch (Portland, OR USA) ★ p73
Klutch, best known as the cranky old punk

Mike Taylor, *People Get Ready (to stay broke)*, 2006 screen print, 12" x 17.5"

responsible for the worldwide vinyl record-painting movement, has been creating visual mischief for over two decades. Some people just don't know when to quit.
Klutch.org

Andalusia Knoll (Philadelphia, PA USA) ★ p33
Andalusia Knoll works for Prometheus Radio Projejct (Prometheusradio.org), reports for the worker-run daily international news program Free Speech Radio News (fsrn.org), and is on FSRN's Steering Committee. When she's not doing anything related to radio, Andalusia enjoys riding her bicycle and teaching others how to repair and maintain their bicycles.

Csilla Kosa (Chicago, IL USA) ★ p31
Csilla Kosa came to the U.S. from Romania in 1996. She teaches art at a public high school in Chicago.

Ray Noland, *Cockfight*, 2004
screen print, 18" x 24"

Aaron Krach (New York, NY USA) ⋆ p127
Aaron Krach is an artist and writer who lives on Manhattan's Lower East Side. His first novel, *Half-Life*, was released to critical acclaim in 2004. He regularly creates and exhibits his conceptual projects online, in the street, and in galleries from Seattle to Sao Paulo.
Aaronkrach.com

Josh Kramb (Kingston, NY USA) ⋆ p138
Josh Kramb is a printmaker/painter who works in several media, including ink, coffee, serigraph, paint, intaglio, and digital images.

Nicolas Lampert (Milwaukee, WI USA) ⋆ p106
Nicolas Lampert is a Milwaukee- and Chicago-based interdisciplinary artist and an author whose work focuses on themes of social justice and ecology. He co-curated the traveling DIY political art show *Drawing Resistance* (2001-2005) and works with the Justseeds Artists' Cooperative.
Machineanimalcollages.com

Sharri LaPierre (Vancouver, WA USA) ⋆ p41
barebonesart@comcast.net

Jim Larriva (Alamosa, CO USA) ⋆ p38
Jimlarriva.com

Setu Legi/Taring Padi (Yogyakarta, Indonesia) ⋆ p105
IISG.nl/collections/taring.php

Marc Lepson (Brooklyn, NY USA) ⋆ p88
Lepson.info

David Lester (Vancouver, Canada) ⋆ p81
David Lester is the guitar player in the underground rock duo Mecca Normal, which also present an inspired lecture/presentation called "How Art & Music Can Change The World." His book *The Gruesome Acts of Capitalism* is in its second printing. He continues to make his poster series *Inspired Agitators*.
Myspace.com/meccanormal

Gabba Levtchenko (Berlin, Germany) ⋆ p28
Beatleprint.de/fleischerei/frameset.html

Alex Lilly (Portland, OR USA) ⋆ p79
Alex Lilly is a political artist/activist. He is often mis-understood. "No one deserves success if others are oppressed."
Zeroriotcop.blogspot.com

Daniel P. LoBue (Friday Harbor, WA USA) ⋆ p117
Daniel LoBue is a working artist and teacher on San Juan Island, Washington. He has studied painting in Rome, Italy and is a graduate of the University of Washington.
danlobue@hotmail.com

Dave Loewenstein (Lawrence, KS USA) ⋆ p56-57
Davidloewenstein.com

Geraldine Lozano (San Diego, CA USA) ⋆ p88
Born in Peru and currently working in California, Geraldine Lozano is an investigator of attachments to place, culture, identity, fears and desires, in order to free them in visuals made with the patters of time. She emphasizes the imagination as being an attribute of our soul, not our mind.
Geralozano.com

Josh MacPhee (Brooklyn, NY USA) ⋆ p10
Josh MacPhee is an artist, curator and activist whose work often revolves around themes of social movements, history, and public space. His previous book is *Reproduce & Revolt* (Soft Skull Press, 2008, co-edited with Favianna Rodriguez). He also organizes the Celebrate People's History Poster Series and is part of the political art cooperative Justseeds.
Justseeds.org

MAGMO the Destroyer (Narragansett, RI USA) ⋆ p106
Magmothedestroyer.org

Fernando Martí (San Francisco, CA USA) ⋆ p110-111
Fernando Martí is a San Francisco-based printmaker, installation artist, and community architect who was born in Guayaquil, Ecuador. Fernando's art explores the clash of the Third World in the heart of Empire, and the tension between claiming place and history and the urge to build something transformative. Fernando works with the San Francisco Print Collective, the Justseeds Artists' Cooperative, and other groups.
Fernandomarti.carbonmade.org

Colin Matthes (Milwaukee, WI USA) ⋆ p41
Colin Matthes works with the radical art cooperative Justseeds (justseeds.org). His solo projects include wall drawings, installations, public art, prints, and zines. He lives, works, and drinks in Milwaukee.
Ideasinpictures.org

MEEK (Melbourne, Australia) ⋆ p106
Stencilgraffiticapital.com

Stephen Melkisethian (Annapolis Junction, MD USA) ⋆ p37
Stephen Melkisethian is a Maryland-based photographer who's been documenting public protest and the police reaction to it over the past ten years, mainly in his home town of Washington, DC.
DCphotographs.com

Nathan Meltz (Troy, NY USA) ⋆ p30
Thehouseoftomorrow.blogspot.com

Dylan A.T. Miner (East Lansing, MI USA) ⋆ p131
Dylan A.T. Miner, Ph.D., is an assistant professor of transcultural studies at Michigan State University. He writes on social movement art, particularly within Native and Latina/o communities. His comics are included in *Studs Terkel's Working: A Graphic Adaptation* (The New Press) and *Wobblies!: A Graphic History of the Industrial Workers of the World* (Verso).
Dylanminer.com

Doug Minkler (Berkeley, CA USA) ⋆ p72
Doug Minkler is a poster maker specializing in fund raising, outreach and educational posters for social justice organizations. Past collaborations include work with the ILWU, Rainforest Action Network, the San Francisco Mime Troupe, ACLU, the National Lawyers Guild, CISPES, United Auto Workers, Africa Information Network, Ecumenical Peace Union, ADAPT, Copwatch, *Street Sheet*, and Veterans for Peace.
Dminkler.com

Claude Moller (San Francisco, CA USA) ⋆ p51
Claude Moller is an artist/community organizer who cut his first stencil in 1985 to protest America's bloated war spending. He makes street art for housing justice groups and fantasizes about anti-yuppie lynch mobs.
Warui.com/stefan/claude

Monkey/CBS (Berlin, Germany) ⋆ p134
Flickr.com/photos/cbs_fan

Shannon Muegge (Toronto, Canada) ⋆ p114
Punchclock.org/workers/shannonmuegge

Ray Noland (Chicago, IL USA) ⋆ p144
Ray Noland is an artist and designer working under the alias CRO. He is the creator of *Go Tell Mama!*, a grassroots Obama art, video, and street campaign that toured the country during the 2008 election. Though Noland's work has been displayed in galleries across the U.S., he is more familiar with renting vacant storefronts and converting them into DIY art spaces.
Creativerescue.org

Ryan Nuckel (Brooklyn, NY USA) ⋆ p94
Ghostbikes.org

Mackenzie Ogilvie (Montreal, Canada) ⋆ p105
Revolutionmontreal.com

Ryan O'Malley (Davidson, NC USA) ⋆ p122
www3.davidson.edu/cms/x31735.xml

Roger Peet (Portland, OR USA) ⋆ p81
Roger Peet is a maker of papercuts, linocuts and stencils. He is part of the Justseeds Artists' Cooperative and his art tends to address extinction, hubris, and ecological catastrophe.
Justseeds.org

Peripheral Media Projects (Brooklyn, NY USA) ⋆ p29
PMP is a group of artists, designers, printers, and activists. They are committed to promoting awareness and social transformation through the creation of art and design, and to fostering community. It is time to change the system. Your assistance is requested and required.
Peripheralmediaprojects.com

Sarah Nicole Phillips (Brooklyn, NY USA) ⋆ p98
Sarahnicolephillips.com

Patrick A. Piazza (San Francisco, CA USA) ⋆ p17
SFPrintCollective.com

Stefan Pilipa (Toronto, Canada) ⋆ p39
Stefan Pilipa is a welder. He lives in Toronto.
Punchclock.org

Endi Poskovic (Ann Arbor, MI USA) ⋆ p30
Best known for his large-scale color woodcuts, Endi Poskovic has exhibited in virtually all the major international print biennales and triennials in the U.S. and abroad, most recently the Biennale internationale d'estampe contemporaine de Trois-Rivières, the Egyptian International Triennial, and the Deutsche Internationale Grafik-Triennale Frechen. He teaches at the University of Michigan School of Art and Design.
Art-design.umich.edu/faculty.php?aud=e&menucat=pe&id=poskovic

Emily Ann Pothast (Seattle, WA USA) ⋆ p36
Emily Ann Pothast is a visual artist, musician and essayist based in Seattle. She has an MFA in printmaking from the University of Washington and currently works as the director of the Antique Print Department at Davidson Galleries.
Emilypothast.com

Freya Powell (Ridgewood, NY USA) ⋆ p116
Freyapowell.com

Jesse Purcell (Montreal, Canada) ⋆ p41
Jesse Purcell is an artist and professional printmaker. He is a member of the Justseeds Artists' Cooperative, and has produced posters with a number of social justice organizations.
Justseeds.org

Ally Reeves (Pittsburgh, PA USA) ⋆ p117
Ally Reeves is an artist from Tennessee who now lives and works in Mumbai, India. Reeves' work addresses issues of information-sharing, empowerment, and alternative economies.

Reynolds (Brooklyn, NY USA) ⋆ p76-77
Reynoldsnart.com

Amy Rice (Minneapolis, MN USA) ⋆ p128
Egg-basket-full-of-hollyhock-dolls.blogspot.com

Favianna Rodriguez (Oakland, CA USA) ⋆ p103
Favianna.com

Rorshach (Richmond, VA USA) ⋆ p73
Rorshach is in the eye of the beholder.
Ghostprint.com

Joshua Pablo Rosenstock (Rosindale, MA USA) ⋆ p63
Joshua Pablo Rosenstock is an artist, musician, and educator. He has presented work in venues as diverse as the Ann Arbor Film Festival; Cabaret Voltaire in Zürich, Switzerland; the Dislocate festival in Yokohama, Japan; the Peggy Notebaert Nature Museum in Chicago; and the Montreal Anarchist Book Fair. He is an assistant professor of interactive media and game development at Worcester Polytechnic Institute.
Joshuarosenstock.com

Joan Stuart Ross (Seattle, WA USA) ⋆ p124
Joan Stuart Ross is an active painter, printmaker and teacher. Joan is especially interested in color dynamics, texture, and layers of concealed and revealed meaning.
Joanstuartross.com

Valerie Roybal (Albuquerque, NM USA) ⋆ p49
Valerieroybal.com

Chris Rubino (Brooklyn, NY USA) ∗ p48
Chris Rubino is a New York City-based artist/designer whose work has been exhibited in Europe, Japan, Hong Kong, and the U.S. Rubino was recently chosen as an ADC Young Gun.
Chrisrubino.com

Erik Ruin (Philadelphia, PA USA) ∗ p92-93
Erik Ruin is a printmaker, shadow-puppeteer, and editor, most recently of *Realizing the Impossible: Art Against Authority*. His recent theatrical work focuses on creating "epic theater" projects (such as the dystopian allegorical musical *The Nothing Factory*) that incorporate dramatic performance, live music, projections, and banner shows to create a total experience. As a visual artist, he frequently works collaboratively with other artists and activist campaigns.
Justseeds.org

Run Don't Walk (Buenos Aires, Argentina) ∗ p94
Rundontwalk.com.ar

Ryan J. Saari (Oakland, CA USA) ∗ p28
Not My Government production has been producing and distributing seditious images since 1996. NMG started printing and handing out stickers calling attention to police repression. Over the years NMG has expanded subjects to include the whole gamut of anti-authoritarian causes with images on formats ranging from vinyl stickers to fine art screen prints to buttons, T-shirts, and several fanzines. NMG is proud to be the home of the star pig campaign.
Notmygovernment.com

Ellen Schillace (St. Paul, MN USA) ∗ p122
Born in Washington,DC, Ellen Schillace has been drawing images that capture compassion, tenderness, love, and the importance of community and connection, since she was a child.
Ellenschillace.com

Nicole Schulman (Brooklyn, NY USA) ∗ p109
Nicoleschulman.com

Sam Sebren (Athens, NY USA) ∗ p45
Sam Sebren has been making art with love and guts in every medium imaginable and displaying it legally and illegally for about thirty years. He's also had several music projects, most notably the '90s New York City post-noise band Splotch, which recorded two records on Menlo Park Recordings. Sam currently lives in the Hudson Valley, where he's involved in various environmental and social justice causes as well as in ongoing art and music projects.

Seripop (Montreal, Canada) ∗ p105
Seripop.com

Erik Siador (Los Angeles, CA USA) ∗ p72
Eriksiador.com

Sue Simensky Bietila (Milwaukee, WI USA) ∗ p18
Drawingresistance.org

Sixten (Montreal, Canada) ∗ p85
Sixten is one of the forces behind Stencilrevolution.com and also cowrote the book *Stencil Graffiti Capital: Melbourne*. In 2007 his work was included in the permanent collection of the National Gallery of Australia. Originally from Sweden, Sixten currently lives in Montreal.
Thismachinekills.com

elin o'Hara slavick (Chapel Hill, NC USA) ∗ p122
elin o'Hara slavick is a conceptual artist and distinguished professor of art, theory and practice at the University of North Carolina at Chapel Hill. Her work has been exhibited across the U.S. and in Canada, Cuba, France, Italy, the Netherlands, the UK and Hong Kong. *Bomb After Bomb: A Violent Cartography*, with a foreword by Howard Zinn, is a monograph of her work (Charta Art Books, Milan, Italy, 2007).
Unc.edu/~eoslavic

Shaun Slifer (Pittsburgh, PA USA) ∗ p134
Shaun Slifer is a multidisciplinary artist currently working in Pittsburgh. He works both alone and collaboratively with the Howling Mob Society and the Justseeds Artists' Cooperative, practices organic plant and mushroom gardening, has a penchant for researching radical North American history, and is a decent bicycle mechanic.
Sslifer.net

Jen Smith (Los Angeles, CA USA) ∗ p97
grande_dame@yahoo.com

Refugio Solis (Mexico City, Mexico) ∗ p97
A Mexican experimental artist, Refugio Solis

makes copyleft images for social movements in Mexico.

Larry Sommers (Seattle, WA USA/1953-2009) ⋆ p72
Emilypothast.wordpress.com/2009/04/03/larry-sommers/

Spazmat (Long Beach, CA USA) ⋆ p45
Skullphone.com

Bert Stabler (Chicago, IL USA) ⋆ p42
Bert Stabler is an art teacher, writer, artist, and curator in Chicago.
Bertstabler.com

Miriam Klein Stahl (Berkeley, CA USA) ⋆ p132-133
Miriam Klein Stahl is an educator, artist, gardener, and mother.
Kleinfamily.etsy.com

Brandon Stahlman (Portland, OR USA) ⋆ p99
Factoryb.com

Chris Stain (Queens, NY USA) ⋆ p43
Chrisstain.com

Jeff Stark (Brooklyn, NY USA) ⋆ p140
Nonsensenyc.com

Mike Stephens (Corpus Christi, TX USA) ⋆ p62
Woodencyclops.com

Meredith Stern (Providence, RI USA) ⋆ p134
Meredith Stern spends much of her free time working in her garden, playing the drums, and working on linoleum block prints.
Justseeds.org

Swoon (Port Orange, FL USA) ⋆ p4
Swoon is a printmaker and street/installation artist whose larger-than-life woodblock prints and cut paper portraits can be found on walls in various states of beautiful decay in cities around the world. She is an international artist with major works in the Museum of Modern Art, P.S.1 Contemporary Art Center, the Brooklyn Museum, and the Tate Modern. For the past several years, Swoon has been traveling around the world creating extraordinary exhibitions and innovative workshops.
swoonifer@gmail.com

Nat Swope (Oakland, CA USA) ⋆ p46-47
Nat Swope lives in Oakland with his wife Cheryl and their son Ethan.
Bloompress.com

Ginger Brooks Takahashi (Brooklyn, NY USA) ⋆ p132-133
Ginger Brooks Takahashi (b. 1977) lives in Brooklyn and maintains a social, project-based practice. She cofounded *LTTR*, a queer and feminist art journal, and projet MOBILIVRE/BOOKMOBILE project, a traveling exhibit of artist books and zines. She is currently a resident at the Center for Book Arts in New York and on tour around the world with the live band MEN.
Brookstakahashi.com

Mike Taylor (Providence, RI USA) ⋆ p143
Mike Taylor draws and paints about uncertainties and speculative fictions. He lives at various points off I-95.
Emptymountain.org

Mark Thomann (Berlin, Germany) ⋆ p122
A silkscreen printer and performance artist, Mark Thomann is a member of the Pony Pedro Collective.
Pony-pedro.de

Sara Thustra (San Francisco, CA USA) ⋆ p126
Gregscott.us/sara.html

Seth Tobocman (New York, NY USA) ⋆ p108
Worldwar3illustrated.org

Rocky Tobey (Toronto, Canada) ⋆ p105
Rocky Tobey began installing anonymous street art as a shoeshine boy in the 1970s. He has bolted books, copper plaques, concrete reliefs, xerox posters and agit-prop billboards on street poles and abandoned buildings in Toronto. For over twenty years Rocky has also produced posters within the anarchist community.
Douglaswalker.ca/rocky/

Mary Tremonte (Pittsburgh, PA USA) ⋆ p127
Mary Tremonte is an artist-educator-DJ who is a member of the Justseeds Artists' Cooperative and the Howling Mob Society. Mary is Youth Programs Coordinator at the Andy Warhol Museum and volunteers at Artists Image Resource. She is consumed with printmaking, totally teens, col-

laboration, communication, and the politics of social space, particularly the dance party.
Justseeds.org

Eric Triantafillou (Chicago, IL USA) ⋆ p22
Eric Triantafillou is a graphic artist, writer, and teacher who lives in Chicago.

Antonia Tricarico (Rome, Italy) ⋆ p85
Antoniatricarico.com

Katie Truskoski (Wakefield, RI USA) ⋆ p121
Katietruskoski.com

Kristine Virsis (Brooklyn, NY USA) ⋆ p90
Justseeds.org

Daryl Vocat (Toronto, Canada) ⋆ p127
Daryl Vocat is a visual artist living and working in Toronto. He completed his BFA degree at the University of Regina in Saskatchewan, and his MFA degree at York University in Toronto. His main focus is printmaking, and specifically screen printing. He works out of Toronto's Open Studio.
Darylvocat.com

Sebastian Wagner (Berlin, Germany) ⋆ p85
Sebastian Wagner is a silkscreen printer and member of the Pony Pedro Collective.
Pony-pedro.de

Dan S. Wang (Madison, WI USA) ⋆ p107
Dan S. Wang is an artist, printer, and writer who works alone and with groups. He helped to co-found the experimental cultural space Mess Hall and he lives in Madison.
Prop-press.vox.com

Rebecca Wayt (Seattle, WA USA) ⋆ p121
Boudiccalllustration.com

Kurt Brian Webb (Palatine, IL USA) ⋆ p58
The Dance of Death tradition persists as one of the most enduring thematic genres in art.

WERC (San Diego, CA USA) ⋆ p32
Werc's work comes from two places; border culture, because he was born in Ciudad Juarez, Mexico and grew up in El Paso, Texas; and graffiti, because the streets were his training ground. He is inspired by logos, symbolism, architecture, urbanization, and immigrant cultures because he sees the beauty in their creative micro-economies that develop sustainability and affordability; and that lead to creations of participatory and collective art projects with intentions of dissolving all borders.
Crolvswerc.com

Watie White (Omaha, NE USA) ⋆ p118-119
Born in 1971 to itinerant cultural anthropologists, Watie White obtained degrees from Carleton College, the School of the Art Institute of Chicago and American University. He is a multidisciplinary artist working in traditional media (painting, printmaking and drawing) and using realist based formal language. The content within his work bears some relationship to the slippery humanist values of truth and honesty.
Watiewhite.com

Jared Wickware (Honolulu, HI USA) ⋆ p125
Jared Wickware is a former U.S. Navy illustrator living in Hawaii. He is active on the board of directors of the Honolulu Printmakers. *Dance on Terror* was in response to 9/11.

Pete Yahnke (Portland, OR USA) ⋆ p124
Pete Yahnke is a printmaker, educator, bicycle rider, and member of the Justseeds Artists' Cooperative.
Justseeds.org

You Are Beautiful (Chicago, IL USA) ⋆ p125
You Are Beautiful is a simple, powerful statement that's incorporated into the over absorption of mass media and lifestyles that are wrapped in consumer culture. The intention behind this project is to reach beyond the artists as individuals to make a difference by creating moments of positive self-realization. The artists are just attempting to make the world a little better.
You-are-beautiful.com

Bec Young (Pittsburgh, PA USA) ⋆ p124
Bec Young is an artist with a diverse range of skills including printmaking, puppet making, fibers, and illustration.
Justseeds.org

Xenios Zittis (Nicosia, Cyprus) ⋆ p32
Xenios Zittis is a cofounder of Rusted Lock Art & Design Studio.
rusted.lock@gmail.com

index

A note on the index:

Image heavy art books are rarely indexed, but because of the unique nature of *Paper Politics*, a collection of artworks which are specifically content-driven, I thought an index was important. I've done my best to index both the text and images, attempting to create a tool which allows readers to draw connections between the essays, the images, and the artist's biographies.

—Josh MacPhee

Dutch Squatter Comics
Seditious Freight Graffiti
Anarchy and Graphic Design
Adventure Playgrounds
The Future of
Xicana Posters
80s Xerox Revolt
Mexico 68 Propaganda

SIGNAL:
A Journal of International
Political Graphics
Edited by Alec "Icky" Dunn
and Josh MacPhee
978-1-60486-091-7
$14.95

Signal is an ongoing book series dedicated to documenting and sharing compelling graphics, art projects, and cultural movements of international resistance and liberation struggles. Artists and cultural workers have been at the center of upheavals and revolts the world over, from the painters and poets in the Paris Commune to the poster makers and street theatre performers of the recent counter globalization movement. *Signal* will bring these artists and their work to a new audience, digging deep through our common history to unearth their images and stories. We have no doubt that *Signal* will come to serve as a unique and irreplaceable resource for activist artists and academic researchers, as well as an active forum for critique of the role of art in revolution.

In the U.S. there is a tendency to focus only on the artworks produced within our shores or from English speaking producers. *Signal* reaches beyond those bounds, bringing material produced the world over, translated from dozens of languages and collected from both the present and decades past. Although a full color printed publication, *Signal* is not limited to the graphic arts. Within its pages you will find political posters and fine arts, comics and murals, street art, site specific works, zines, art collectives, documentation of performance and the often overlooked but essential role all of these have played in struggles around the world.

SLINGSHOT

32 POSTCARDS BY ERIC DROOKER

Slingshot:
32 Postcards by Eric Drooker
Eric Drooker
978-1-60486-016-0
$14.95

Disguised as a book of innocent postcards, Slingshot is a dangerous collection of Eric Drooker's most notorious posters. Plastered on brick walls from New York to Berlin, tattooed on bodies from Kansas to Mexico City, Drooker's graphics continue to infiltrate and inflame the body politic. Drooker is the author of two graphic novels, *Flood! A Novel in Pictures* (winner of the American Book Award), and *Blood Song: A Silent Ballad*. He collaborated with Beat poet Allen Ginsberg on the underground classic, *Illuminated Poems*. His provocative art has appeared on countless posters, book and CD covers, and his hard-edged graphics are a familiar sight on street corners throughout the world. Eric Drooker is a third generation New Yorker, born and raised on Manhattan Island. His paintings are frequently seen on covers of *The New Yorker* magazine, and hang in various art collections throughout the U.S. and Europe.

"Drooker's old Poe hallucinations of beauteous deathly reality transcend political hang-up and fix our present American dreams."
—Allen Ginsberg

"When the rush of war parades are over, a simple and elegant reminder of humanity remains—in the work of Eric Drooker."
—Sue Coe

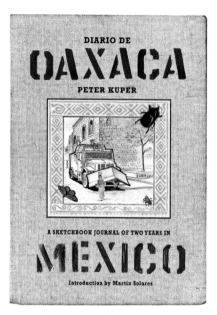

Diario de Oaxaca:
*A Sketchbook Journal of
Two Years in Mexico*
Peter Kuper
978-1-60486-071-9
$29.95

Painting a vivid, personal portrait of social and political upheaval in Oaxaca, Mexico, this unique memoir employs comics, bilingual essays, photos, and sketches to chronicle the events that unfolded around a teachers' strike and led to a seven-month siege.

When award-winning cartoonist Peter Kuper and his wife and daughter moved to the beautiful 16th-century colonial town of Oaxaca in 2006, they planned to spend a quiet year or two enjoying a different culture and taking a break from the U.S. political climate under the Bush administration. What they hadn't counted on was landing in the epicenter of Mexico's biggest political struggle in recent years. Timely and compelling, this extraordinary firsthand account presents a distinct artistic vision of Oaxacan life, from explorations of the beauty of the environment to graphic portrayals of the fight between strikers and government troops that left more than 20 people dead, including American journalist Brad Will.

"Kuper is a colossus; I have been in awe of him for over 20 years. Teachers and students everywhere take heart: Kuper has in these pages born witness to our seemingly endless struggle to educate and to be educated in the face of institutions that really don't give a damn. In this ruined age we need Kuper's unsparing compassionate visionary artistry like we need hope."
—Junot Díaz, Pulitzer Prize winning author of *The Brief Wondrous Life of Oscar Wao*

"Peter Kuper is undoubtedly the modern master whose work has refined the socially relevant comic to the highest point yet achieved." —*Newsarama*

"An artist at the top of his form." —*Publisher's Weekly*

"*Oaxaca Diary* reveals to us how so many aspects of a city can be combined on the same page by an adept artist; poetry, magic, beauty, mystery, fear, as well as the different faces that protest can assume when politicians hold a city hostage…"
—Martín Solares from his introduction

FRIENDS OF

In the year since its founding —and on a mere shoestring —PM Press has risen to the formidable challenge of publishing and distributing knowledge and entertainment for the struggles ahead. With over 40 releases in 2009, we have published an impressive and stimulating array of literature, art, music, politics, and culture. Using every available medium, we've succeeded in connecting those hungry for ideas and information to those putting them into practice.

Friends of PM allows you to directly help impact, amplify, and revitalize the discourse and actions of radical writers, filmmakers, and artists. It provides us with a stable foundation from which we can build upon our early successes and provides a much-needed subsidy for the materials that can't necessarily pay their own way. You can help make that happen—and receive every new title automatically delivered to your door once a month—by joining as a Friend of PM Press. Here are your options:

- • $25 a month: Get all books and pamphlets plus 50% discount on all webstore purchases.
- • $25 a month: Get all CDs and DVDs plus 50% discount on all webstore purchases.
- • $40 a month: Get all PM Press releases plus 50% discount on all webstore purchases
- • $100 a month: Sustainer. - Everything plus PM merchandise, free downloads, and 50% discount on all webstore purchases.

Just go to WWW.PMPRESS.ORG to sign up. Your card will be billed once a month, until you tell us to stop. Or until our efforts succeed in bringing the revolution around. Or the financial meltdown of Capital makes plastic redundant. Whichever comes first.

PM Press was founded at the end of 2007 by a small collection of folks with decades of publishing, media, and organizing experience. PM co-founder Ramsey Kanaan started AK Press as a young teenager in Scotland almost 30 years ago and, together with his fellow PM Press coconspirators, has published and distributed hundreds of books, pamphlets, CDs, and DVDs. Members of PM have founded enduring book fairs, spearheaded victorious tenant organizing campaigns, and worked closely with bookstores, academic conferences, and even rock bands to deliver political and challenging ideas to all walks of life. We're old enough to know what we're doing and young enough to know what's at stake.

We seek to create radical and stimulating fiction and nonfiction books, pamphlets, t-shirts, visual and audio materials to entertain, educate and inspire you. We aim to distribute these through every available channel with every available technology - whether that means you are seeing anarchist classics at our bookfair stalls; reading our latest vegan cookbook at the café; downloading geeky fiction e-books; or digging new music and timely videos from our website.

PM PRESS is always on the lookout for talented and skilled volunteers, artists, activists and writers to work with. If you have a great idea for a project or can contribute in some way, please get in touch.

PM PRESS
PO Box 23912
Oakland CA 94623
510-658-3906
www.pmpress.org